Beirut City Center

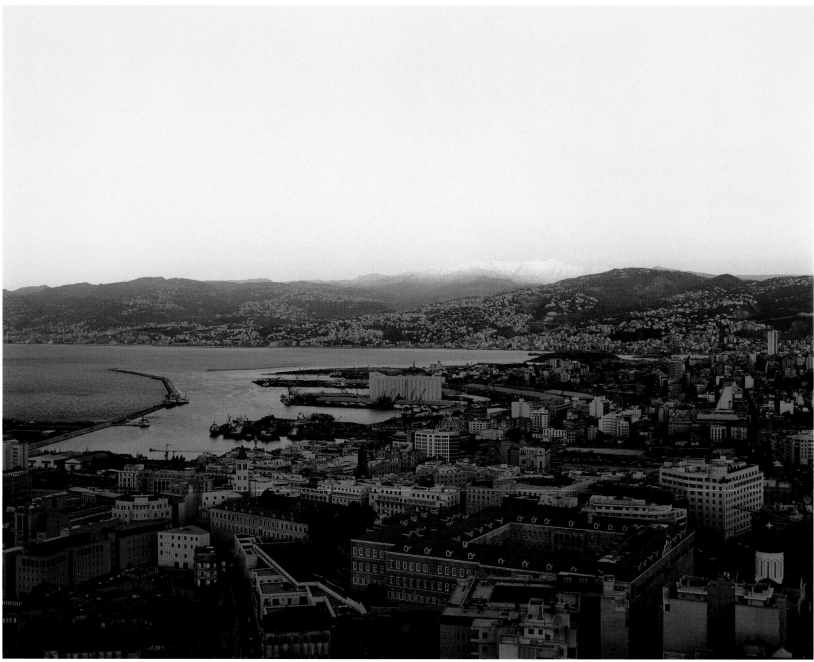

View of Beirut City Center, the Mediterranean Sea, and Mount Sannine at dusk.

Beirut City Center

The waterfront promenade will offer a view of the bay and snow-capped Mount Sannine.

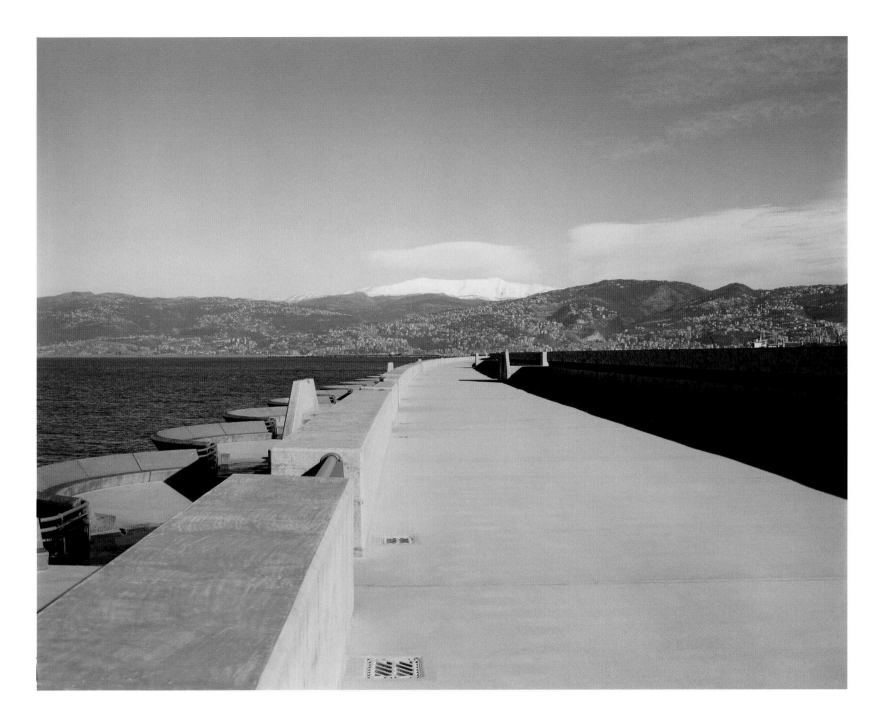

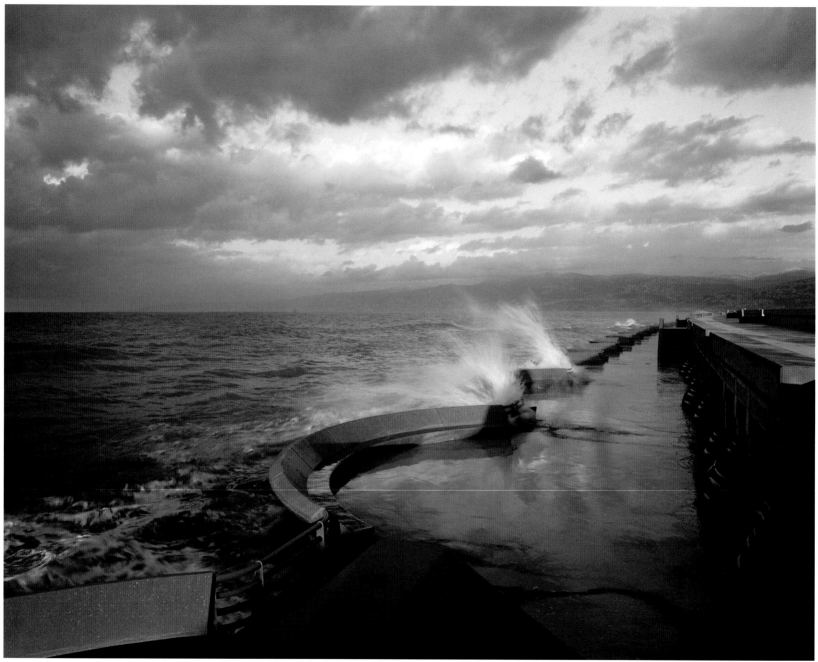

Winter view from the seafront promenade, part of the sea defense protecting the new waterfront.

Foreword

The photographs contained in this album constitute a unique record of the rebuilding of Beirut's city center, begun ten years ago and now poised at its midway point towards completion. Unwittingly or not, as photographed by Larry McPherson, the rehabilitated buildings, streets, gardens, and waterfront seem to be caught in a limbo of transition between the past and the future, startlingly individual in character and somewhat devoid of the kinship shaped by time and the formative imprint of human habitation.

All appears still and waiting. Here, for instance, we see the new waterfront promenade, the tower clock of Nejmeh Square, the Grand Serail, Maraad Street, the wonderfully renovated buildings of Saifi Village - and all along the streets the young trees of tender green that will one day lend their welcome shade. We see the mosques, churches, public buildings, and villas built in another age and seldom noticed before, standing now in royal isolation, like precious specimens of art in a vast outdoor museum.

These buildings, photographed at this point in time, will not be seen again in the same way, in all their solitary splendor. In another fifteen years, when the Solidere reconstruction project is completed, all the spaces now empty will be filled with the new modern structures of a public domain - high-rises and souks, plazas and gardens, traffic overpasses and pedestrian pathways. The Beirut Marina, with its quays and scores of mooring berths, will have become the prime port for yachts and boats from everywhere. And Martyrs' Square, the ageless heart of Beirut, will have been rebuilt to serve as a major commercial center, crowned by a wide landscaped corridor leading to the sea.

By then, the sense of isolation and void we feel now will have been erased. The living fabric of human activity that has already begun to weave its embracing threads of community and brotherly love throughout the streets and byways of the city center will have harmonized the old-new intermix of its buildings - transforming Beirut into a truly united city and blessing its people with revitalized spirit. One can say that this, in essence, was the ultimate dream that fired the vision of Rafic Hariri and inspired the Solidere team.

Nasser Chammaa
Chairman - General Manager
Solidere

Introduction

Photographs, though they may lack descriptive captions, can sometimes convey unexpected revelations of reality to awaken the imagination and unlock forgotten doors of memory. These images of the buildings, mosques, churches, streets, gardens, pathways, and waterfront development of the new Beirut city center, embraced by the wide umbrella of its eternal sky, are like the posed still portraits of people dressed in their Sunday best, wanting their images to be recorded for posterity. Looking at them, one cannot but remember Beirut's past and wonder about its future.

Unlike any other camera images ever caught of downtown Beirut, they were taken by the internationally acclaimed photographer Larry McPherson in the six months he spent in Beirut during the period of May 2002 to July 2004. Focusing his eye on the distinctive linear and formal characteristics of the city's physical anatomy, uncluttered by the passing temporal activity of human life, he took most of his photographs in the quiet, lucid, unpeopled light of early morning. He aimed his lens on the different sections of the cityscape in a direct frontal manner, exercising an impressive esthetic sense of pictorial composition, as he sought to capture the diversity of Beirut's cultural origins and the topographical structure of its seacoast terrain. Rather than just record the buildings and their surroundings as images of architectural beauty to be admired, he wanted to remind us of the inescapable truths they encompass as a living testament to Beirut's eventful past and its persistent will to survive.

As we look at these photos, we cannot but think about the 5,000 years of continuous human habitation that make up Beirut's history - from the Canaanite, Phoenician, Graeco-Roman, and Byzantine ages through the Umayyad, Ottoman, and French Mandate periods. We know this from the surprising wealth of archeological evidence unearthed by fourteen teams of archeologists, working under the supervision of the Directorate General of Antiquities and with the support of Solidere.

Then, as we recall the haunting images of the heart of this city devastated by fifteen years of senseless conflict - its buildings peppered with bullet holes, the vulnerable walls of its ancient structures fallen to pieces and obliterated beyond recognition - and look at the miracle of urban renewal wrought during the past ten years, we marvel at the indomitable power of humankind to rebuild and infuse energy into what was destroyed.

Contained in the images of solitary buildings is an enduring message of hope and promise for Lebanon. McPherson insists that we look upon the buildings as living monuments, wanting us to remember what they once were, embrace what they now are, and hold on to their strength for our future. Curiously, his photographs have impregnated the empty spaces surrounding them with an aura of human spirit seeking to attach itself to the protective haven of an earthbound body. In this sense, he magically transformed the buildings into people.

Each of the images reflects the story of an irretrievable past. Yet, one could also look upon most of the restored buildings as cloned structures - they are, literally, exactly what they were when they were first constructed - their facades perfectly restored to their original style in the authentic materials and workmanship of their origin. Now reborn and modernized with new interiors, they stand as the healing links of Lebanon's past with its present and future.

Rebuilding a city center after it had been almost obliterated by war was a daunting challenge. When Solidere was formed in 1994 with Rafic Hariri as its guiding light and in agreement with the Government of Lebanon, there was much controversy as to its chances for success. In the early years, there were many obstacles to overcome, not only financially, but socially and politically as well. But once the reconstruction master plan, carefully formulated down to the smallest detail, was set, the work proceeded on schedule. As is evident in the photos, restoration and renewal projects are still going on, and the entire project will take many more years to complete.

The public domain was reconstituted through the installation of the new infrastructure and utilities, the creation of parks and gardens, and the preservation of ancient archeological sites. This was accompanied by the restoration of the buildings of the city center's historic core, the redevelopment of the residential areas (such as Saifi Village, Zokak El Blatt and Wadi Abou Jamil), and the construction of major new buildings (such as United Nations House, Banque Audi, the Atrium, An-Nahar, and the Monroe Hotel). Land reclamation has significantly extended the city center beyond the original seashore line; when completed, important residential and hotel projects will be developed there.

The current phase of reconstruction includes the development of this area, as well as the Beirut Souks, the completion of Wadi Abou Jamil as an urban village, and the Hadiqat As-Samah (Garden of Forgiveness). And the city's seaport facilities are being supplemented by a modern-day marina, designed to accommodate hundreds of yachts and sail boats. The major focus over the next several years will be on the development of such new areas as the Martyrs' Square axis, the city center's southern gateway, and the large new waterfront district, which will solidly mark the internationalization of the Solidere project and relaunch Beirut as a world city and a major capital of the Middle East region.

The images included in this book were chosen principally by the photographer. As such, they are subjectively selective and portray only a small part of the reconstruction process. It is our hope, however, that the reader will share with all the people of Lebanon in the visionary legacy of the one man, Rafic Hariri, who made it all possible.

Mediterranean panorama of the city center on a clear winter day.

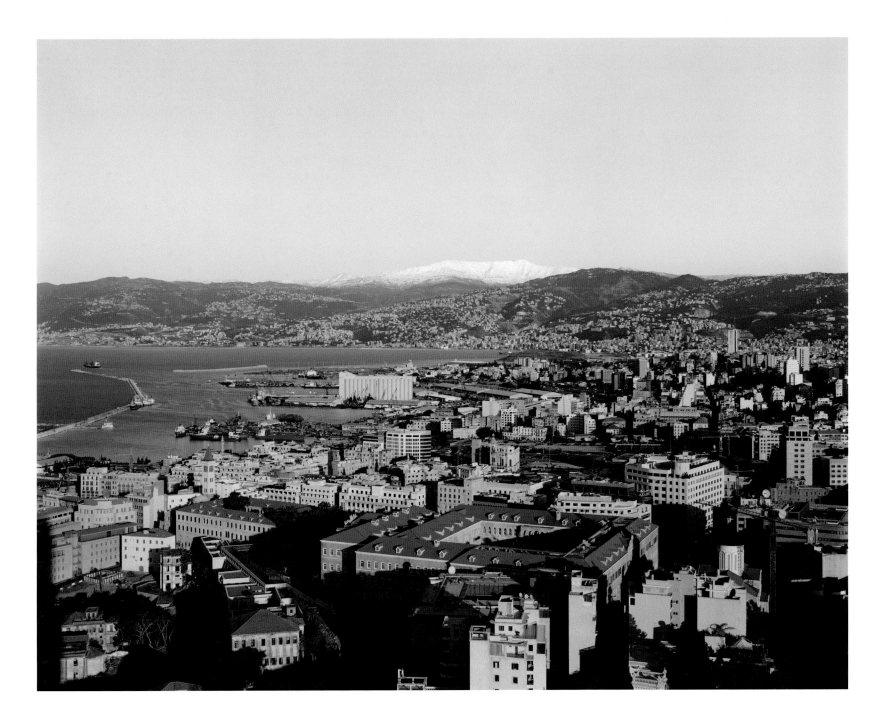

Morning view from the east end of the sea promenade.

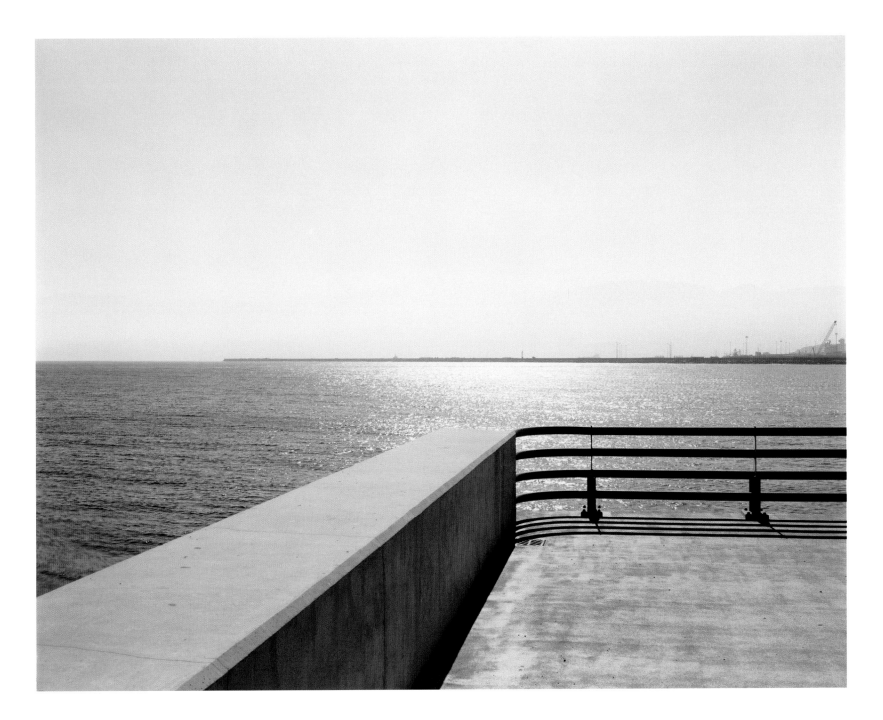

Land reclamation under way on the waterfront.

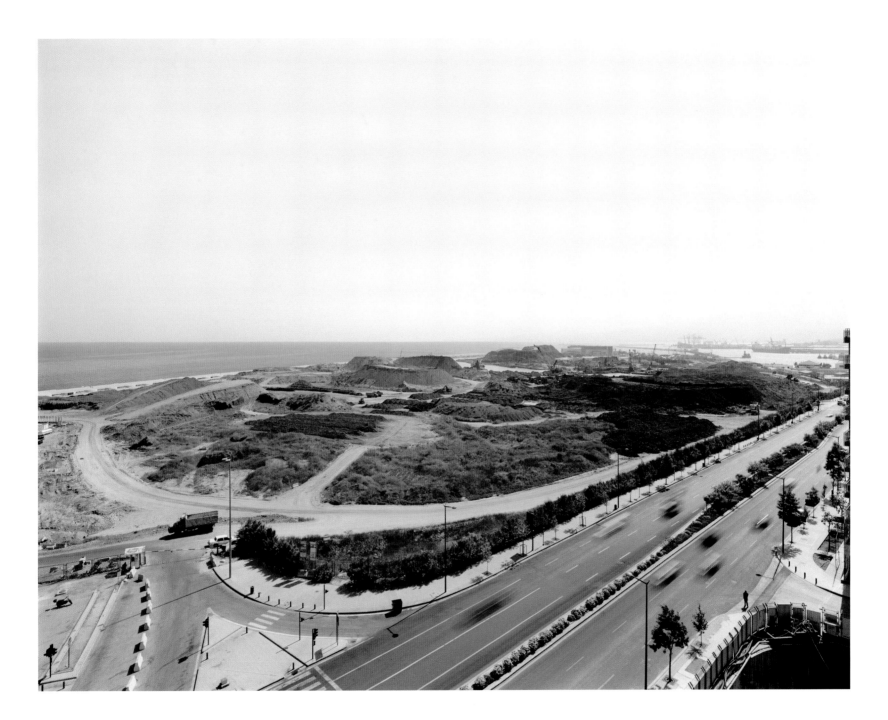

Sorting and drying cleaned materials for the landfill.

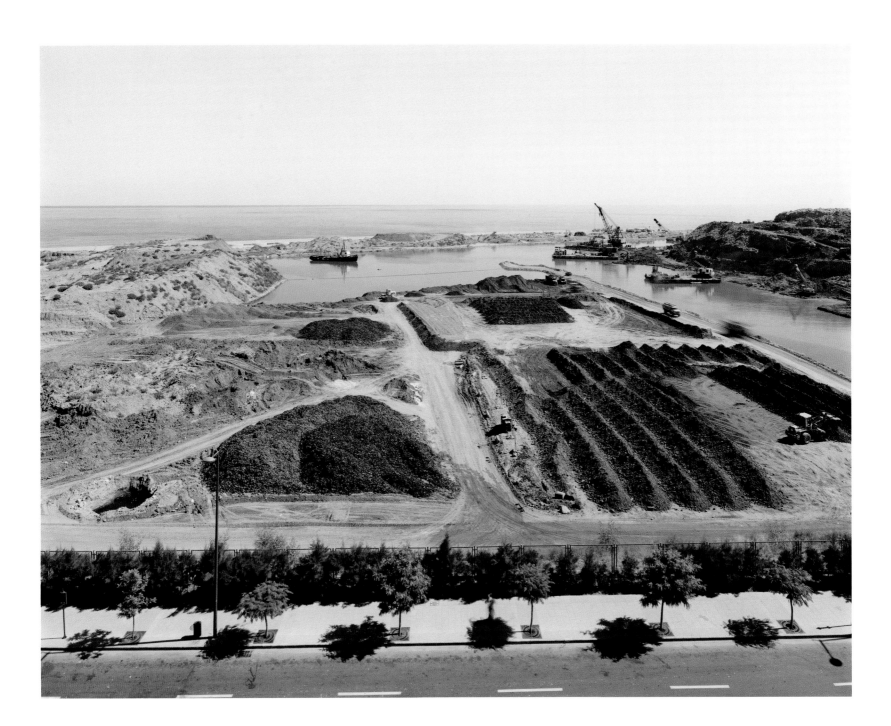

Nejmeh Square, named after Place de l'Etoile in Paris. At the center, the clock tower donated by Lebanese emigrant Miguel Abed was designed by architect Mardirios Altounian and built in 1934.

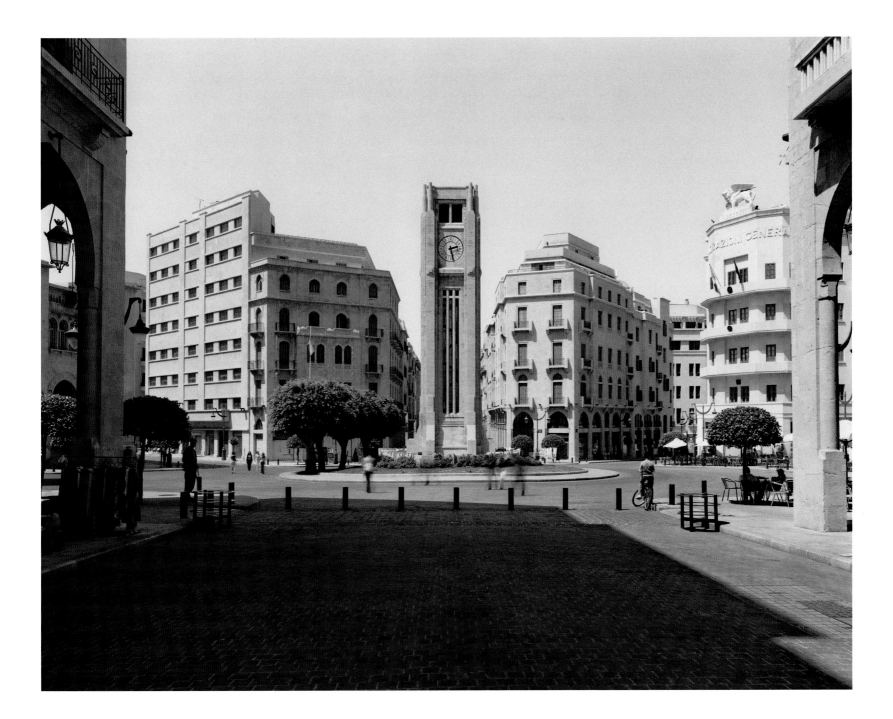

Fountain garden on Rue des Capucins, leading to the St Louis Capuchin Church.

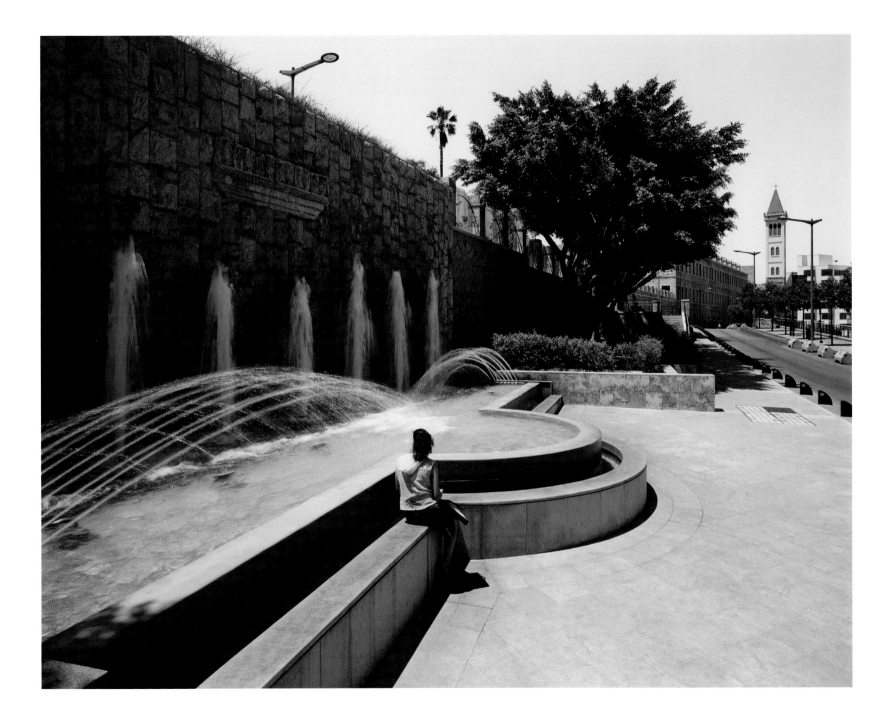

Roman Baths Garden, between the Serail Hill to the left and Banking Street to the right.

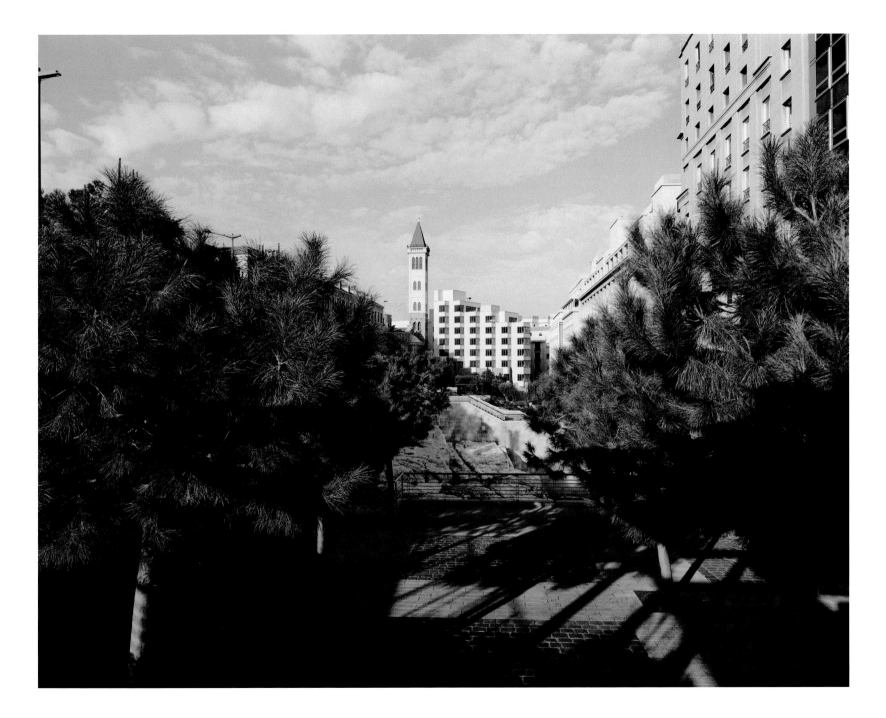

Roman Baths pedestrian area, with stairs leading to the Serail Hill.

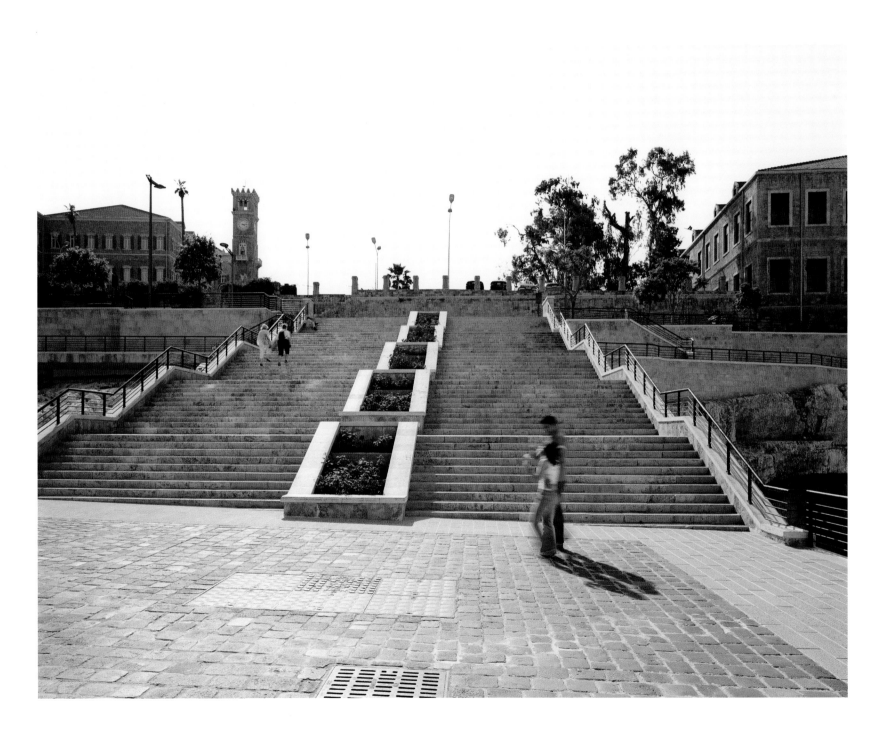

Overview of the Roman Baths, with the aromatic garden typical of ancient times.

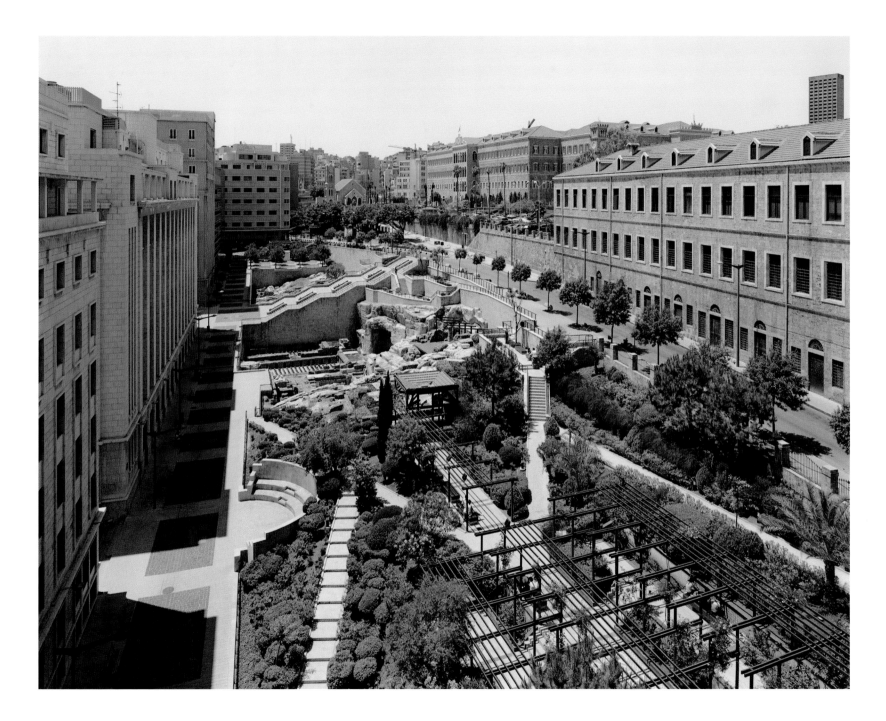

The Roman Baths date back to ancient times, when Beirut was known as Colonia Julia Augusta Felix Berytus.

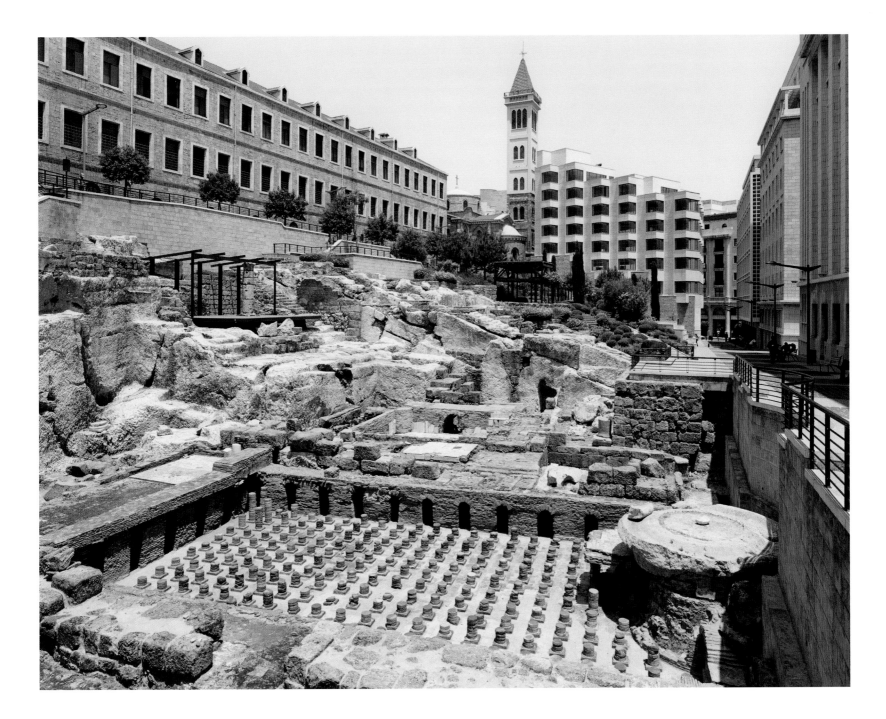

A detail of the archeological remains of the Roman Baths.

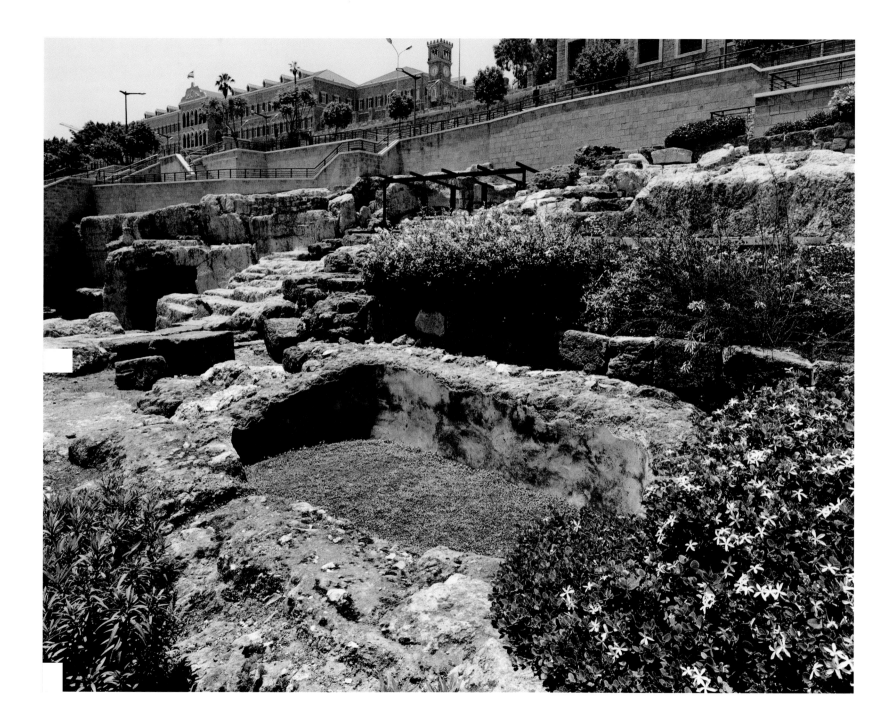

The archeological site chosen as the location for the Garden of Forgiveness (Hadiqat As-Samah), shown before the garden construction began. The garden will be a place for calm reflection, sheltered from the bustle of the city and expressing themes of understanding, forgiveness and unity. It will be surrounded by several historical places of worship, the newly built Mohamad Al Amine Mosque, and the Rafic Hariri memorial and museum.

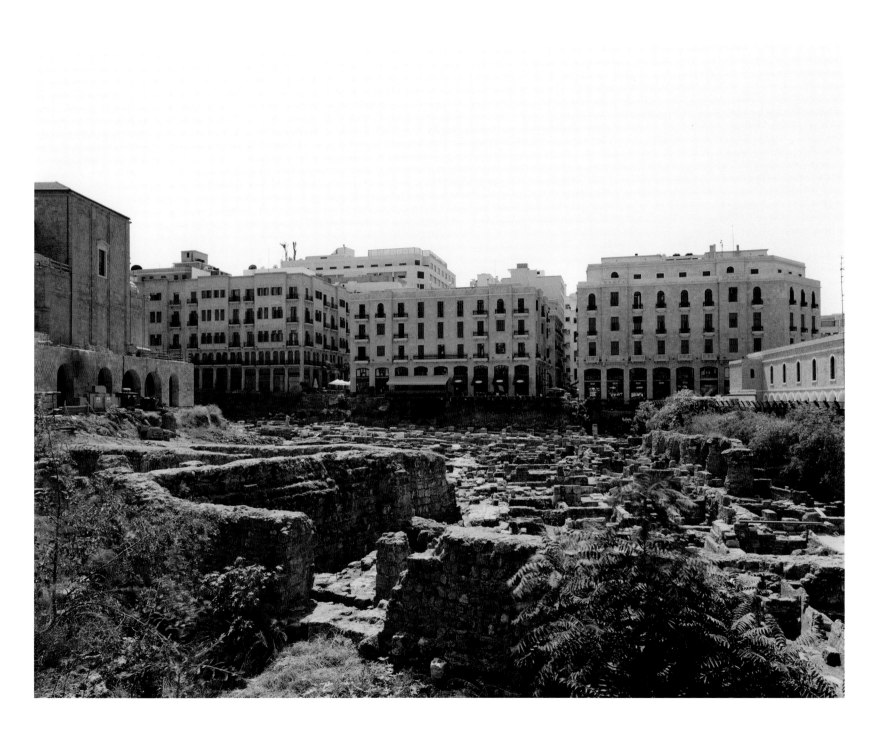

Archeological excavations revealed this Cardo Maximus, the main north-south road during Roman times, which will now form an important feature of the Garden of Forgiveness.

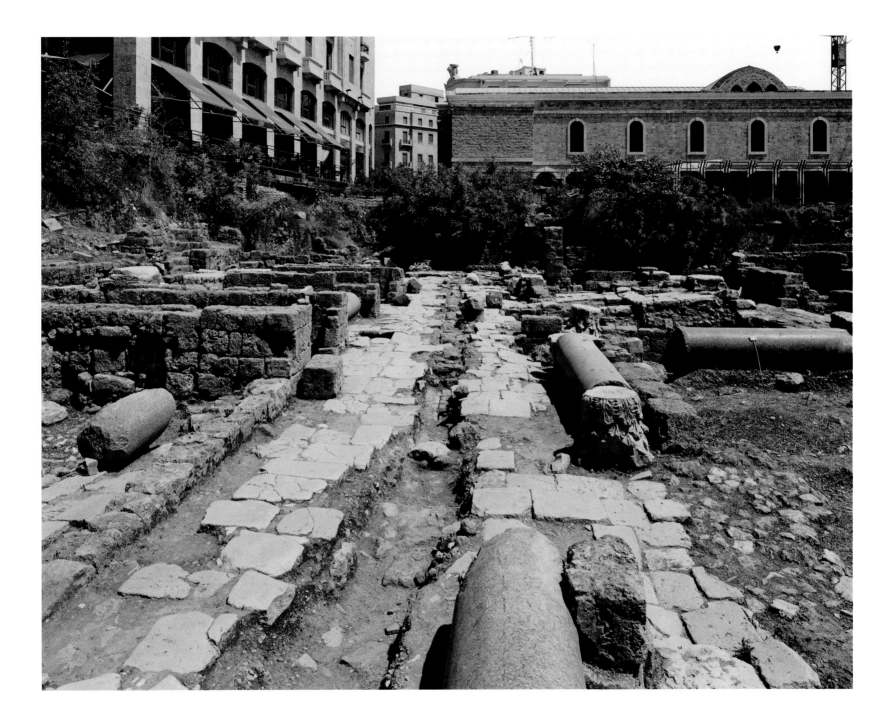

New infrastructure and public space include a ring road, landscaped streets, and gardens.

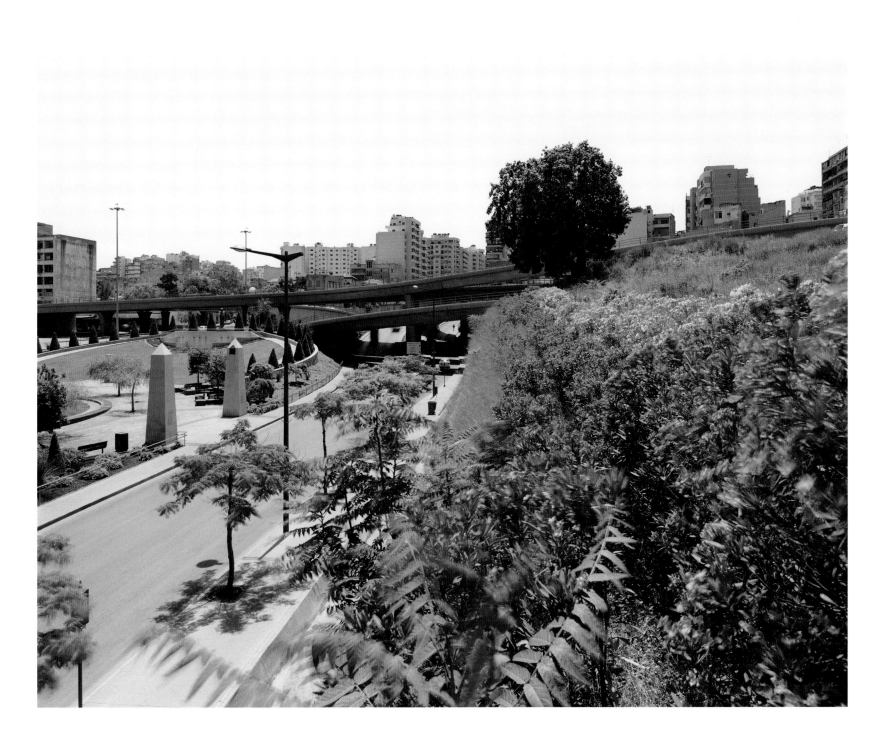

United Nations House with the Gibran Khalil Gibran Garden, named after the Lebanese writer and artist of world renown.

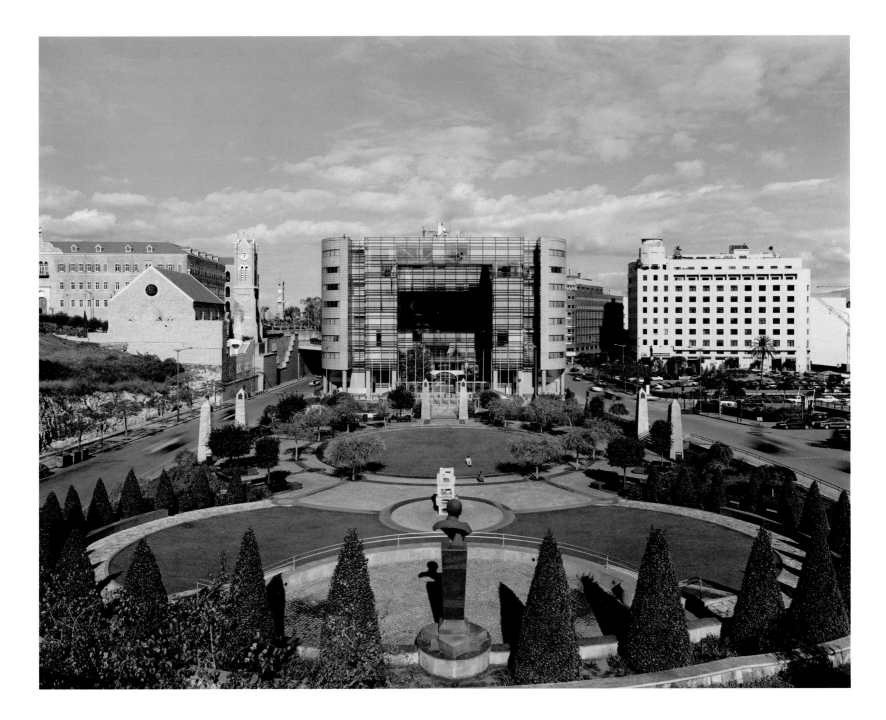

Riad El Solh Square with the restored statue of Riad El Solh, hero of Lebanese independence and the first prime minister of independent Lebanon.

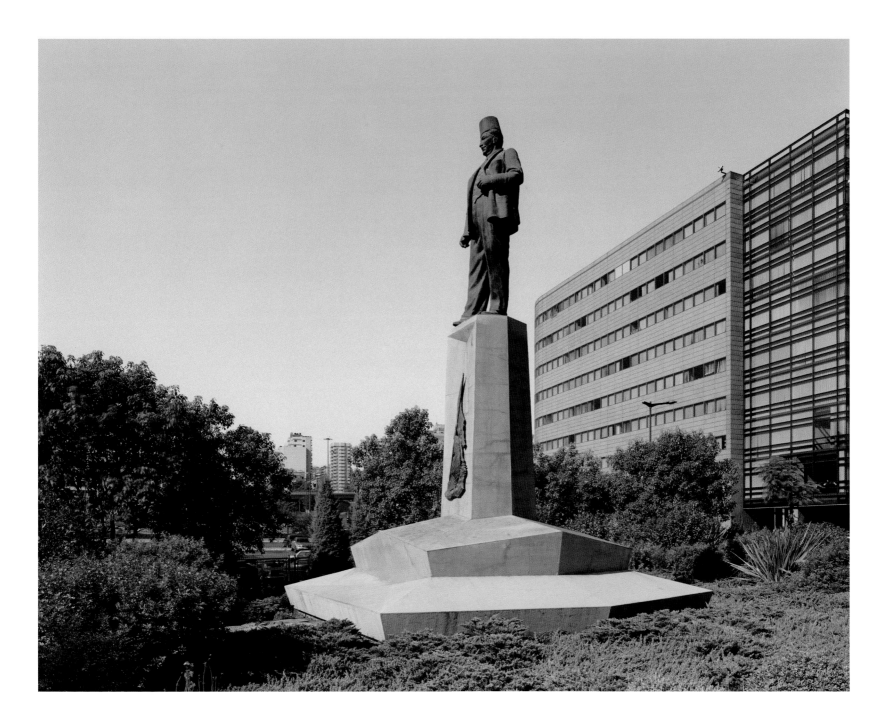

The Fouad Chehab Garden. In the background, a prewar office tower and restored residential quarters.

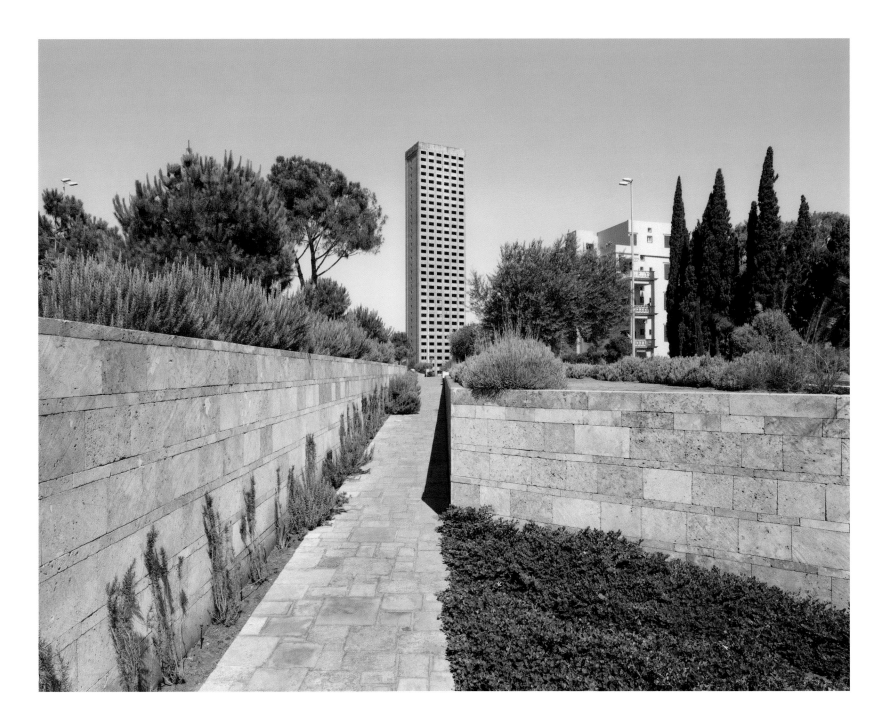

The Fouad Chehab Garden overlooking the city.

Detail of the exterior of the Amir Munzer Mosque, built in 1620 by Amir Munzer Al Tannoukhi.

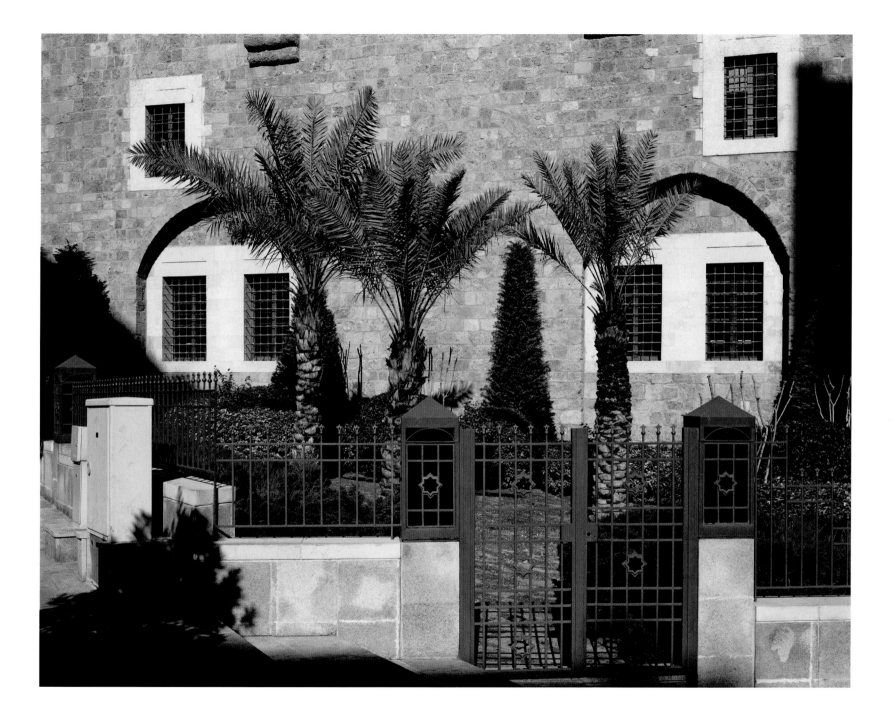

Amir Munzer Mosque internal courtyard.

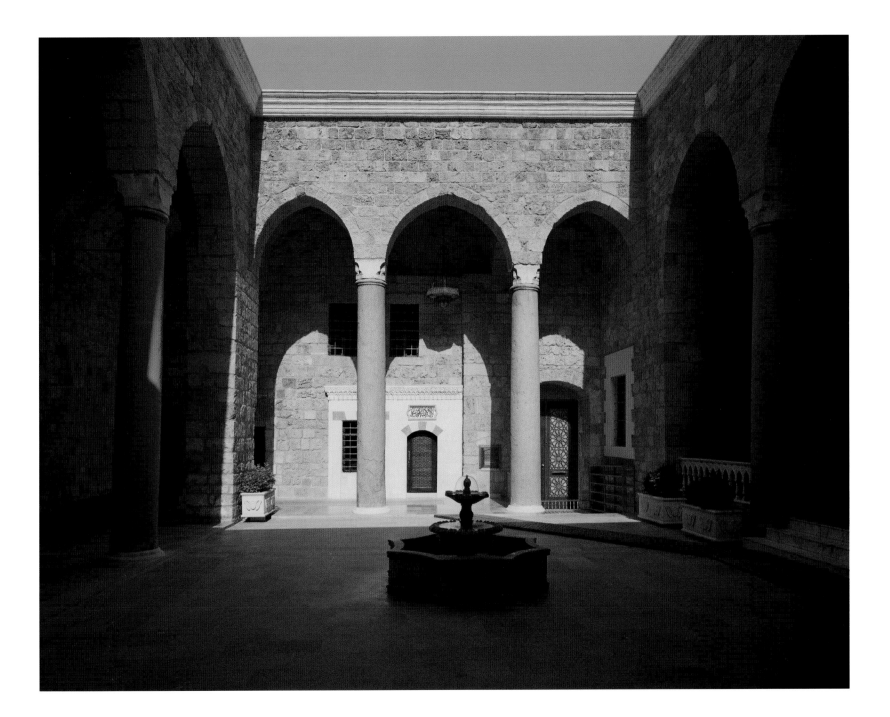

The Serail clock tower, designed by architect Youssef Aftimus and built in 1900 to celebrate the anniversary of the Ottoman Sultan Abdel Hamid II.

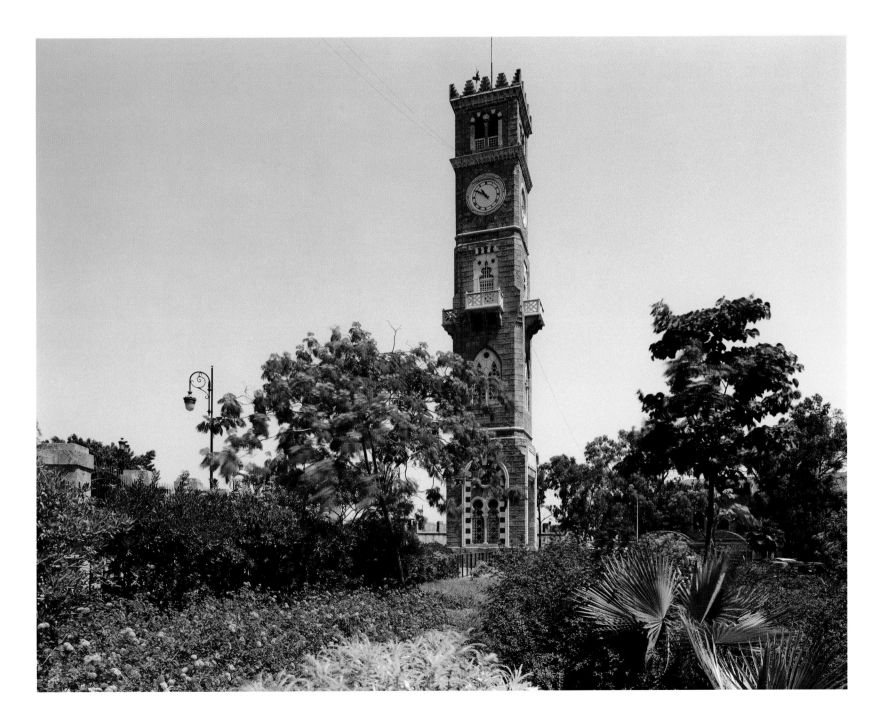

The Grand Serail, from the National Evangelical Church garden.

The Grand Serail internal courtyard.

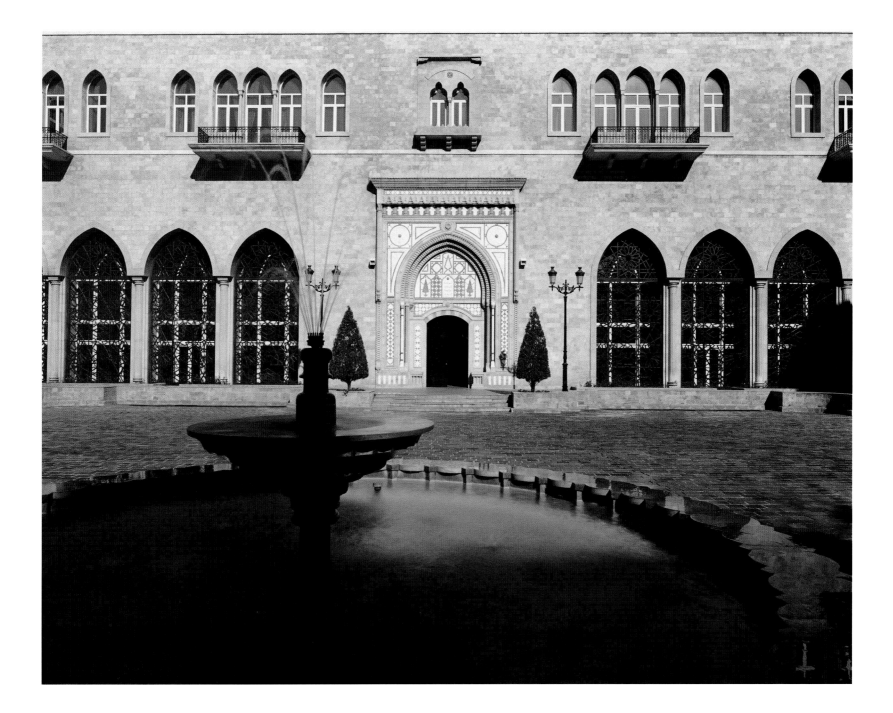

Fountain in the Grand Serail internal courtyard.

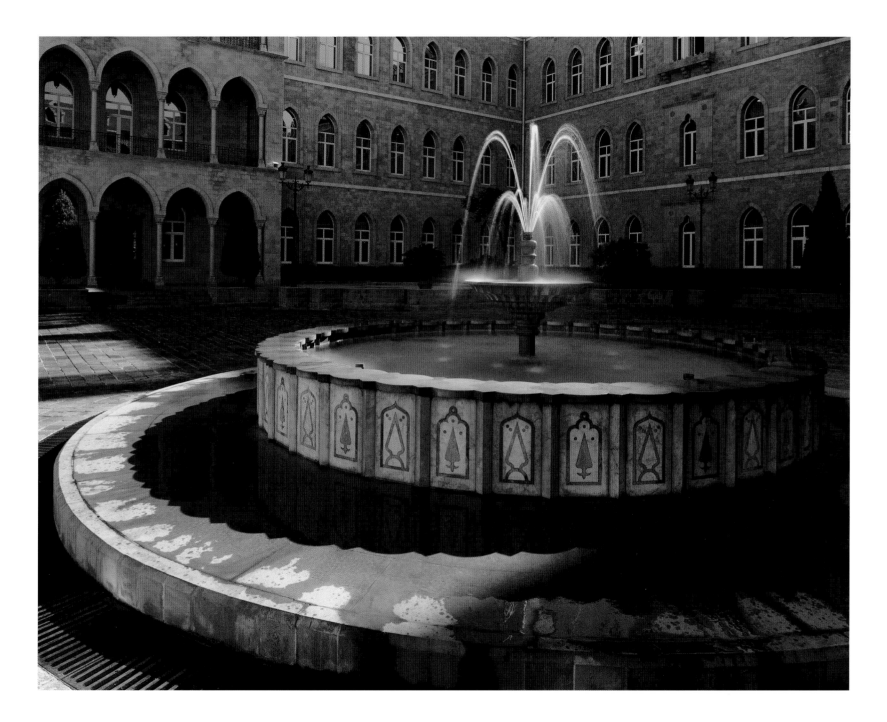

The Art Deco clock tower in the foreground and the Ottoman clock
tower in the background are positioned so there is a clear view between them.
To the right, Parliament Building, designed by architect Mardirios Altounian and
completed in 1934.

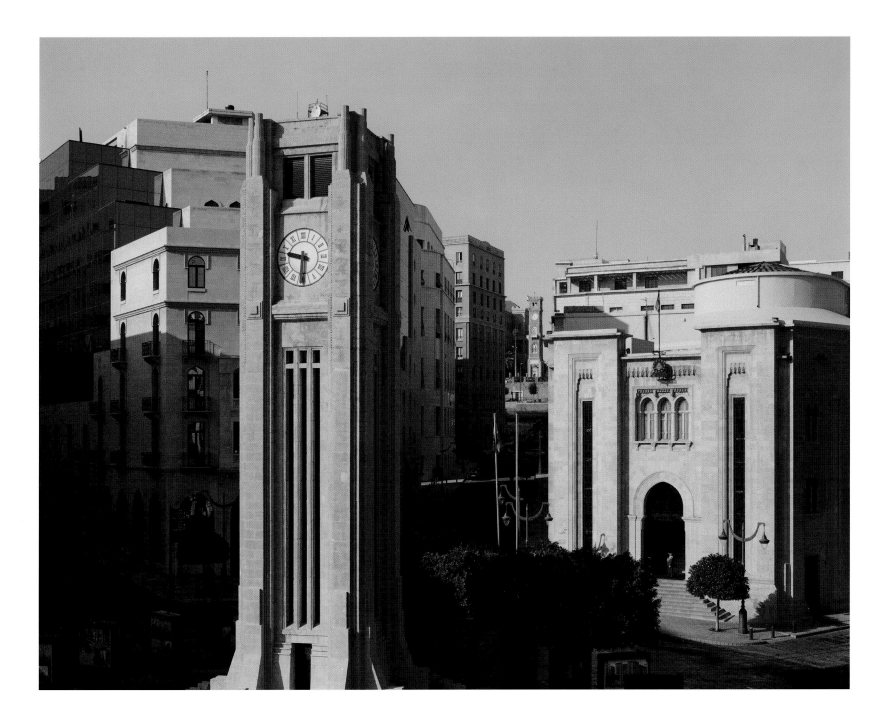

Nejmeh Square with radiating streets.

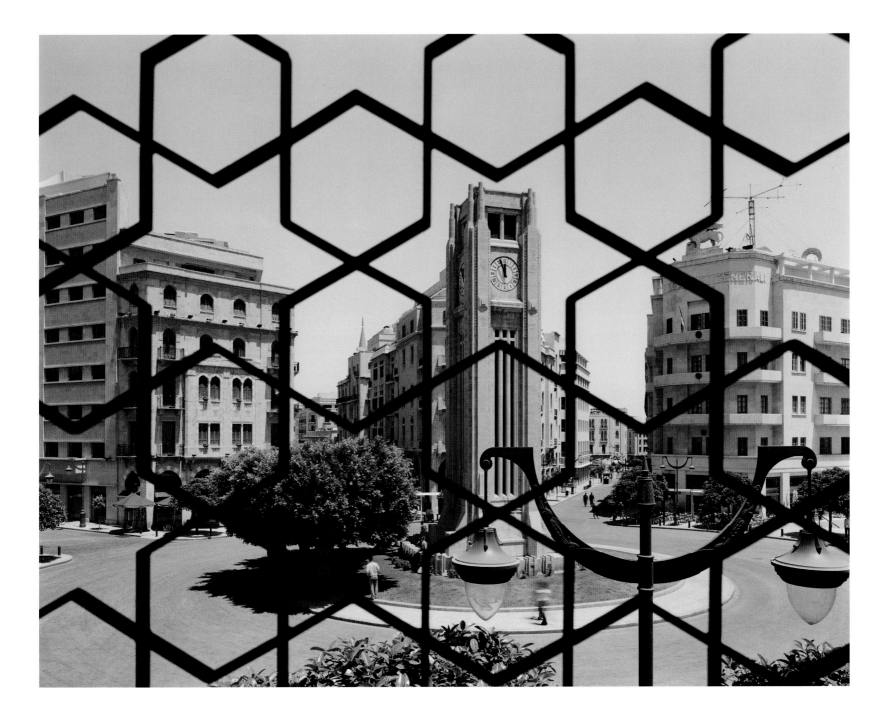

People strolling in Nejmeh Square.

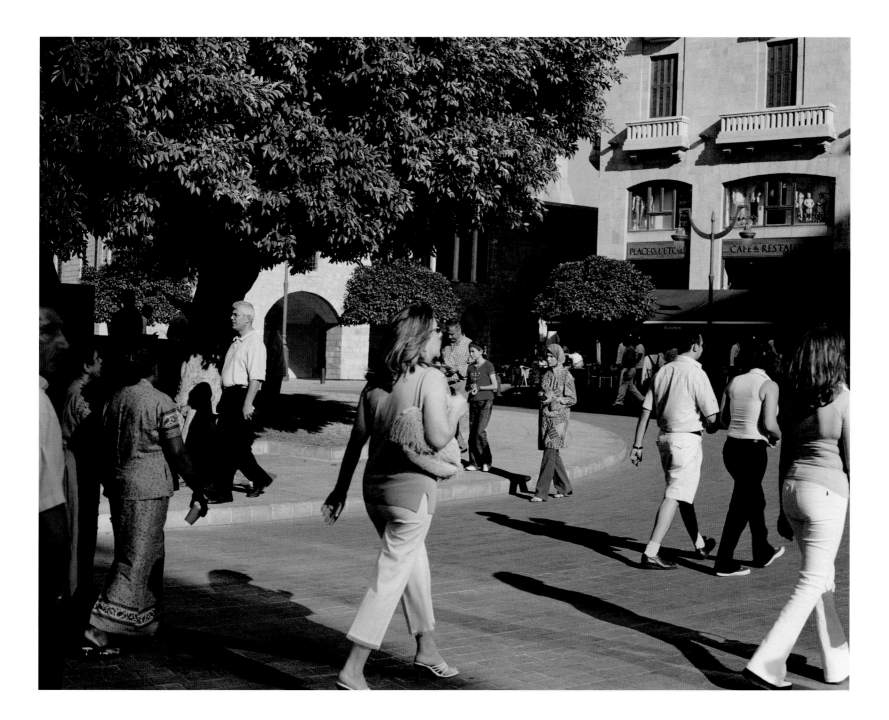

Children in Nejmeh Square.

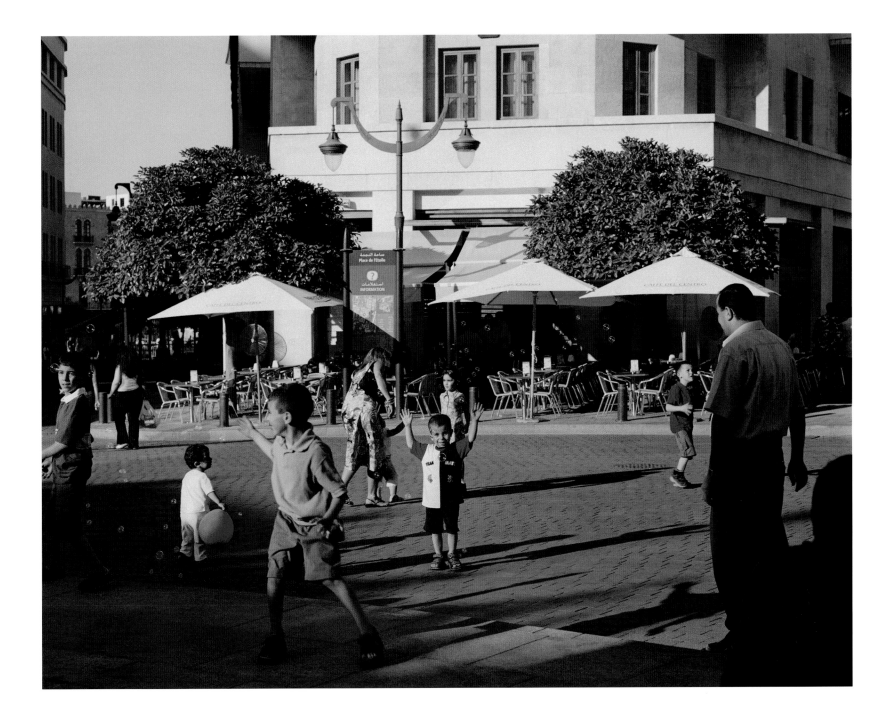

The arcaded Maarad Street, named after the Beirut Fair which took place in 1921.

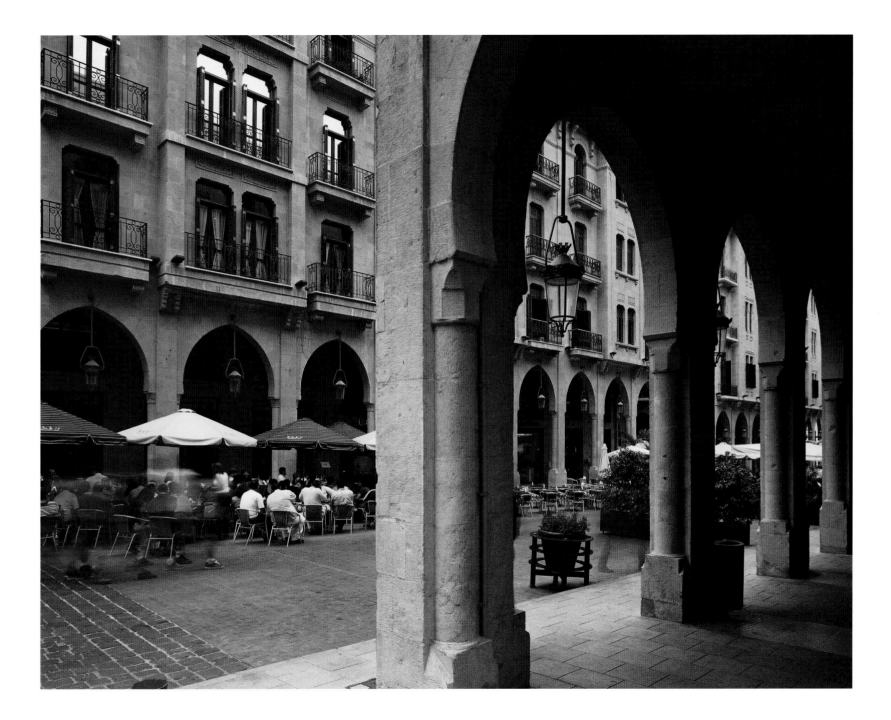

Street café in the Foch-Allenby conservation area.

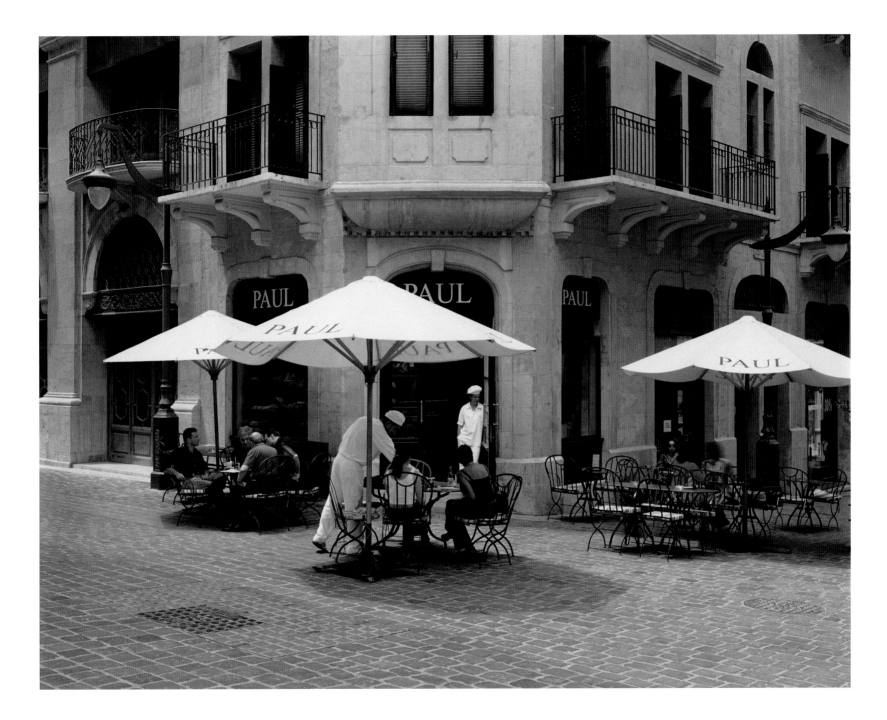

Restored Abou Bakr (Al Dabbagha) Mosque and other buildings along Foch Street, where a façade competition was launched in 1920.

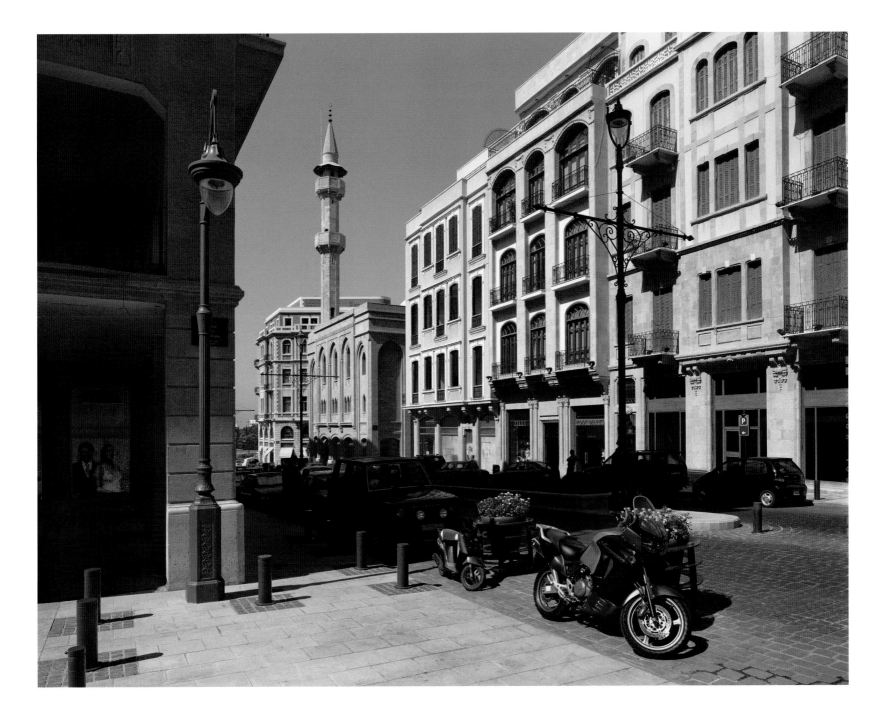

Businessmen in the Foch-Allenby area.

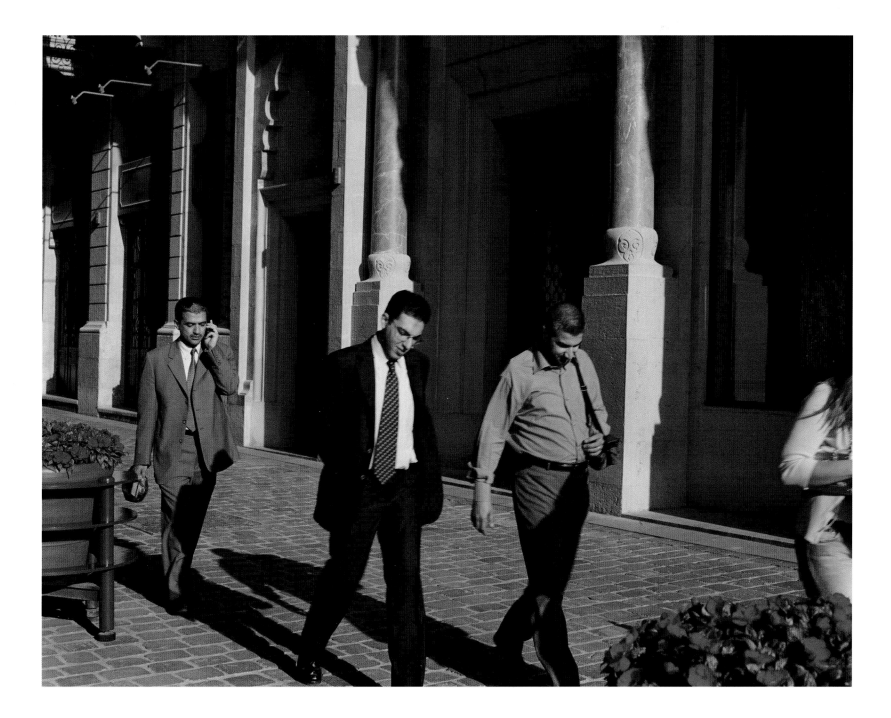

A Foch Street building with restored façade, modern interiors, and basement parking.

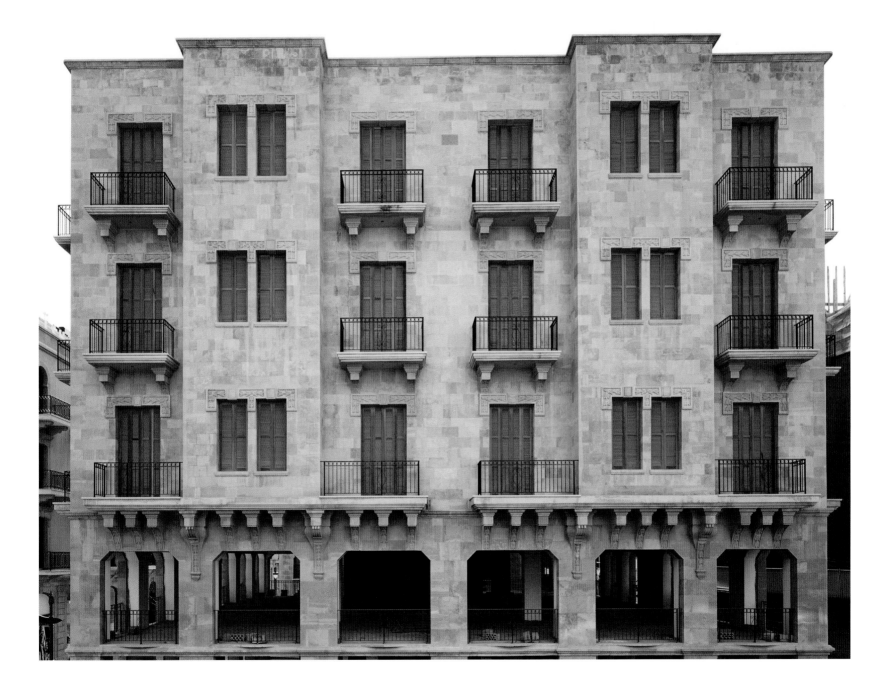

Beirut Municipality Building, designed by architect Youssef Aftimus and built in 1925.

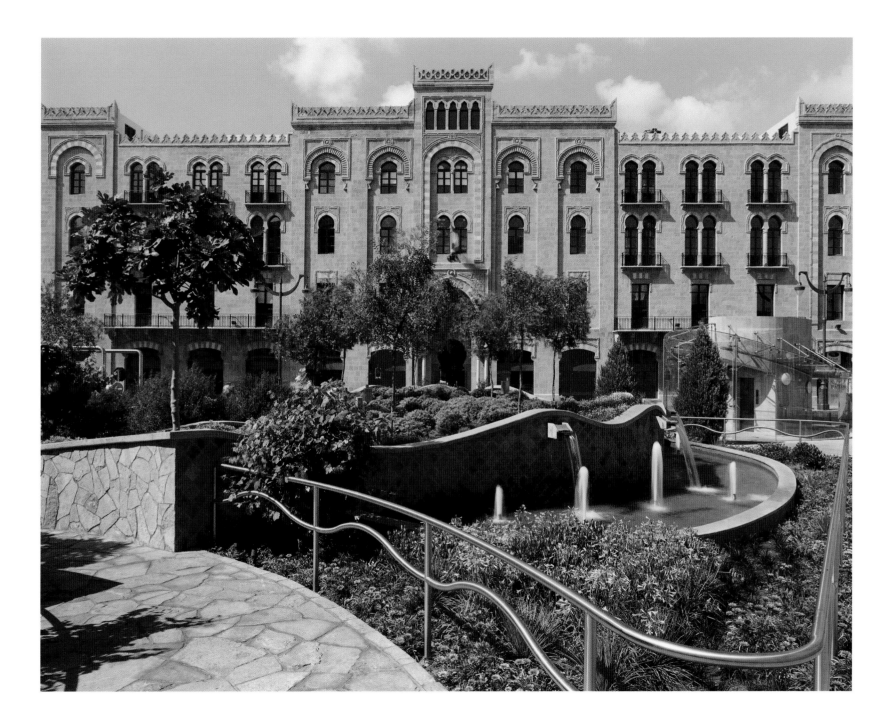

Virgin Megastore, in the former Opera Cinema Building, and UFA Assurances headquarters, in the former Semiramis Hotel.

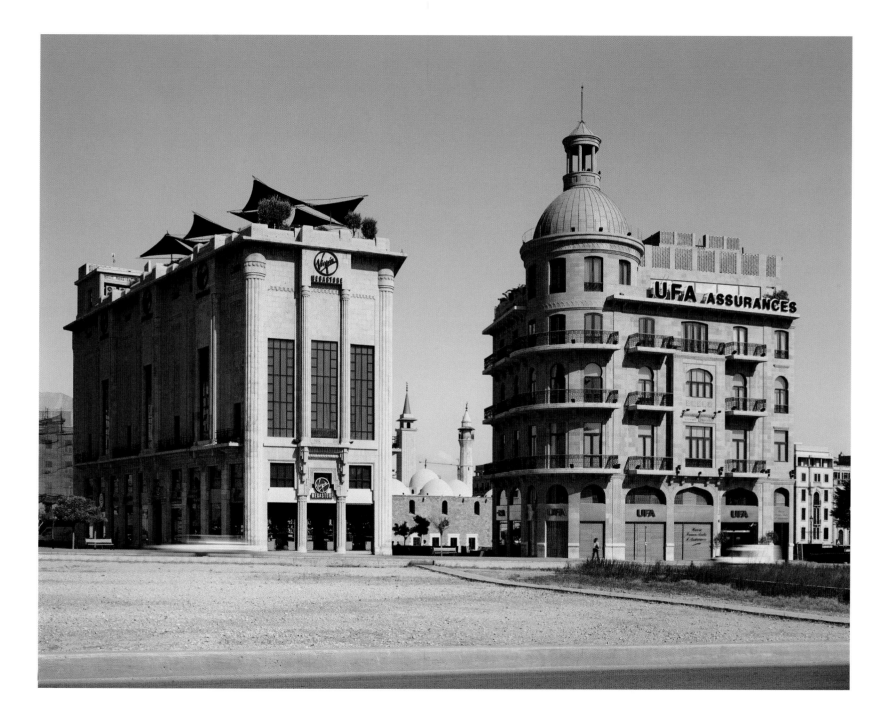

Façade restoration of the former Grand Theatre.

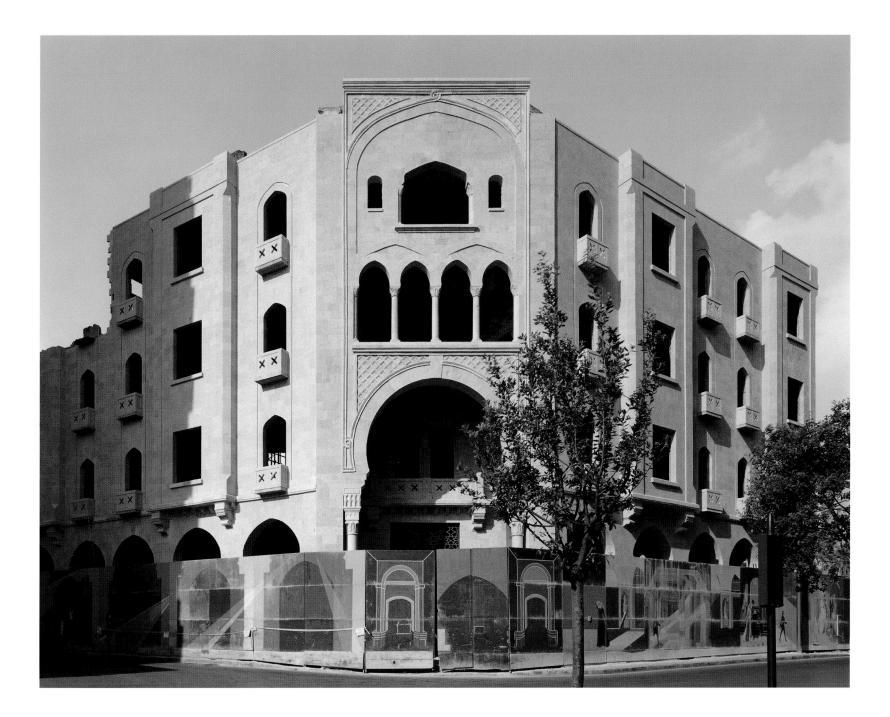

Amir Bachir Street leading to the Grand Theatre, with the Lazariya commercial center to the left.

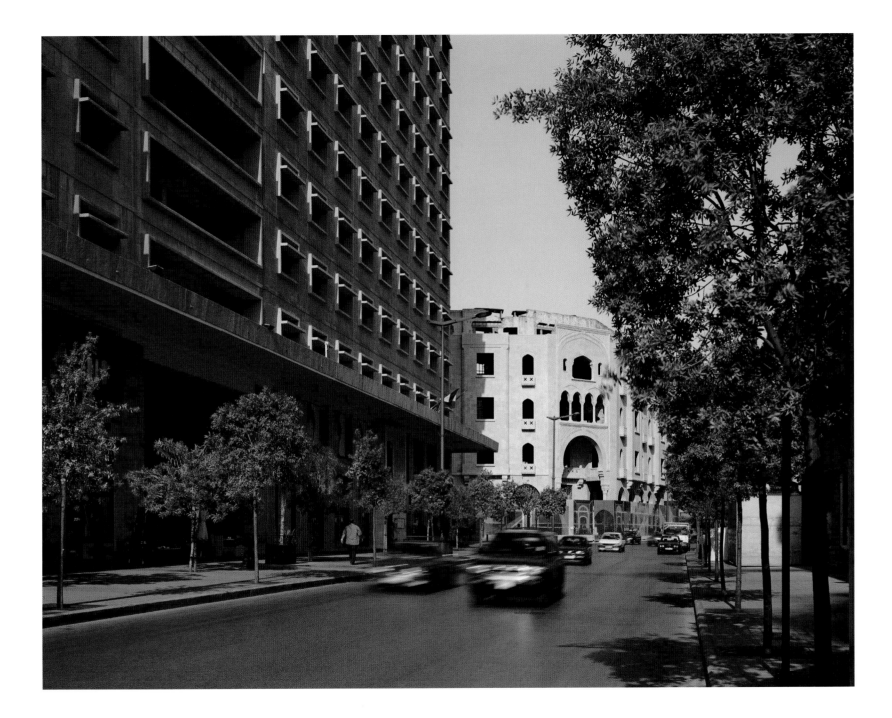

Double perspective of Riad El Solh Street, center of banking activity on the left, and Parliament Street on the right.

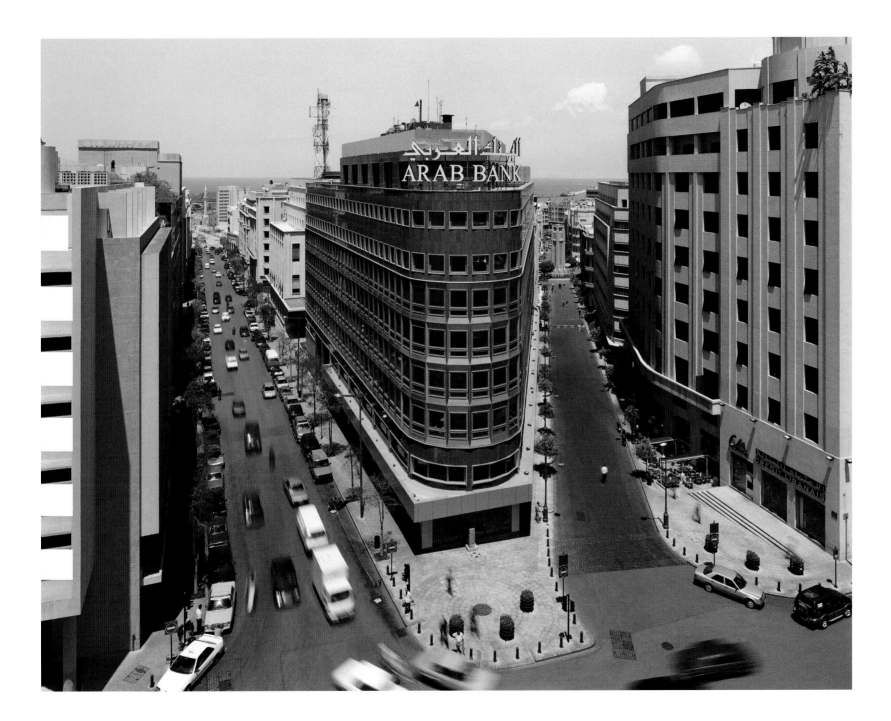

Rooftop view of Parliament Street, with the sea and mountains beyond.

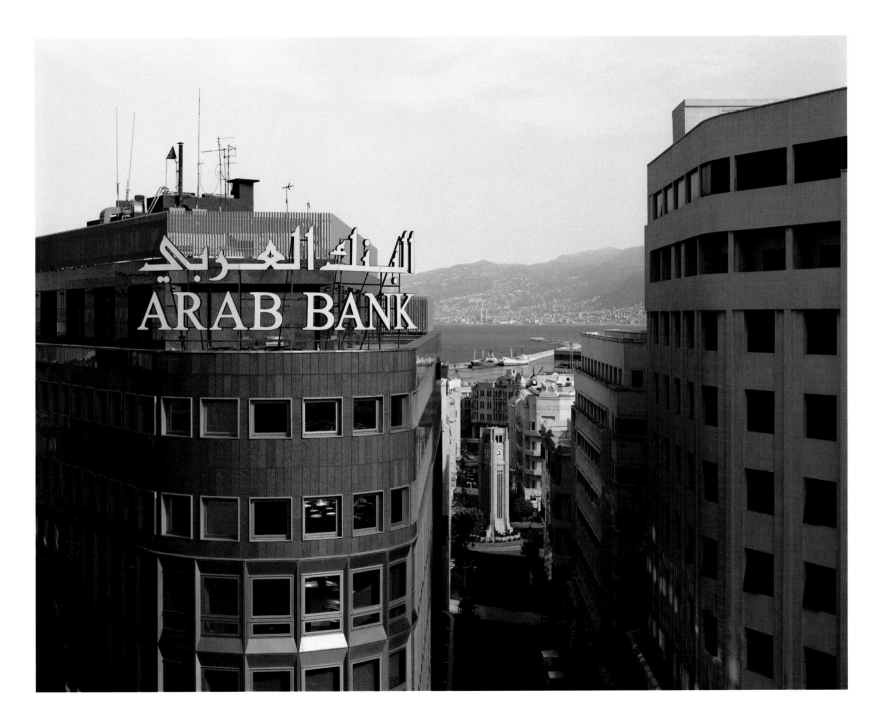

Restored commercial buildings in the northern Foch Street area, between the Ottoman citadel, left, and the Abou Bakr (Al Dabbagha) Mosque, right.

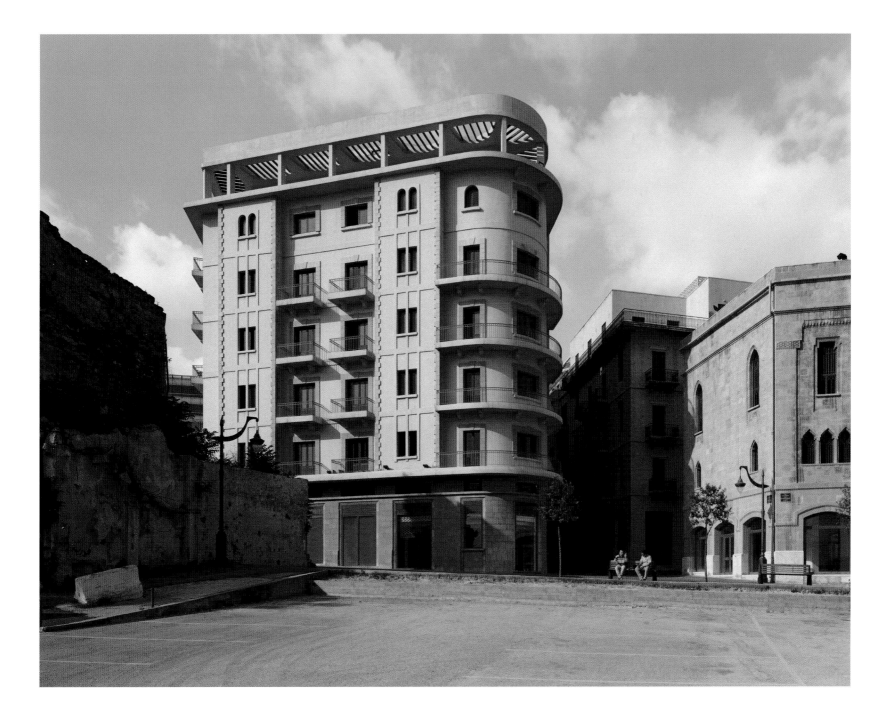

Restored commercial buildings facing Fouad Chehab Street.

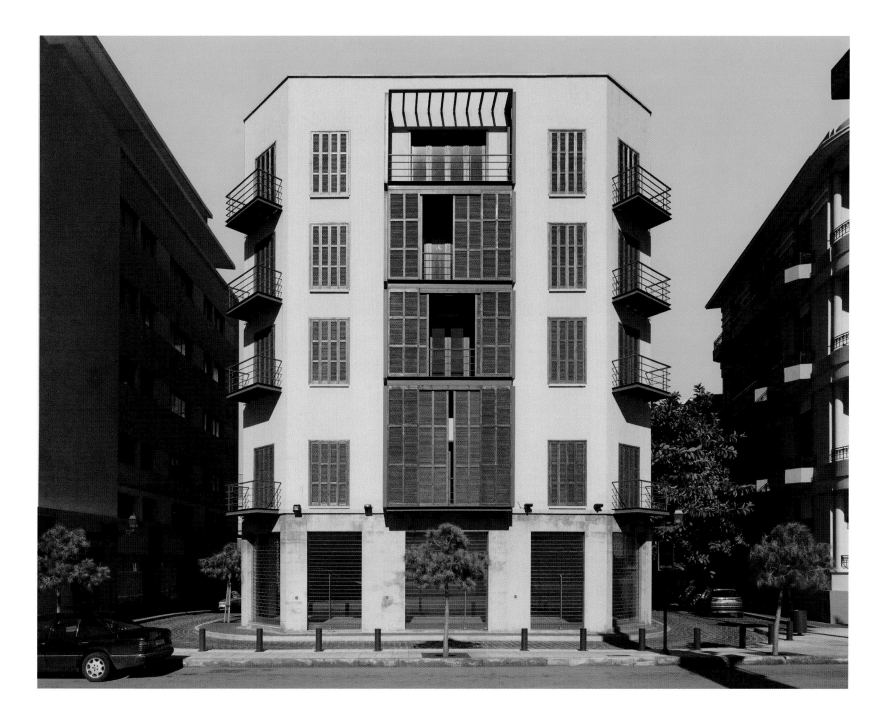

Trieste Street access to the city center, with modern and restored buildings in the background.

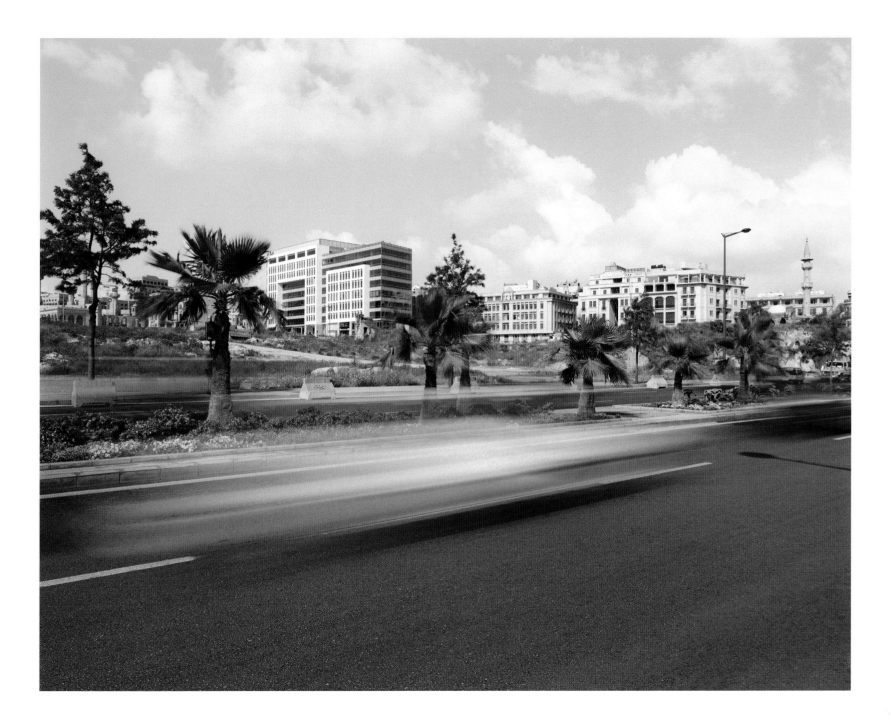

An-Nahar Newspaper headquarters, designed by architect Pierre El Khoury.

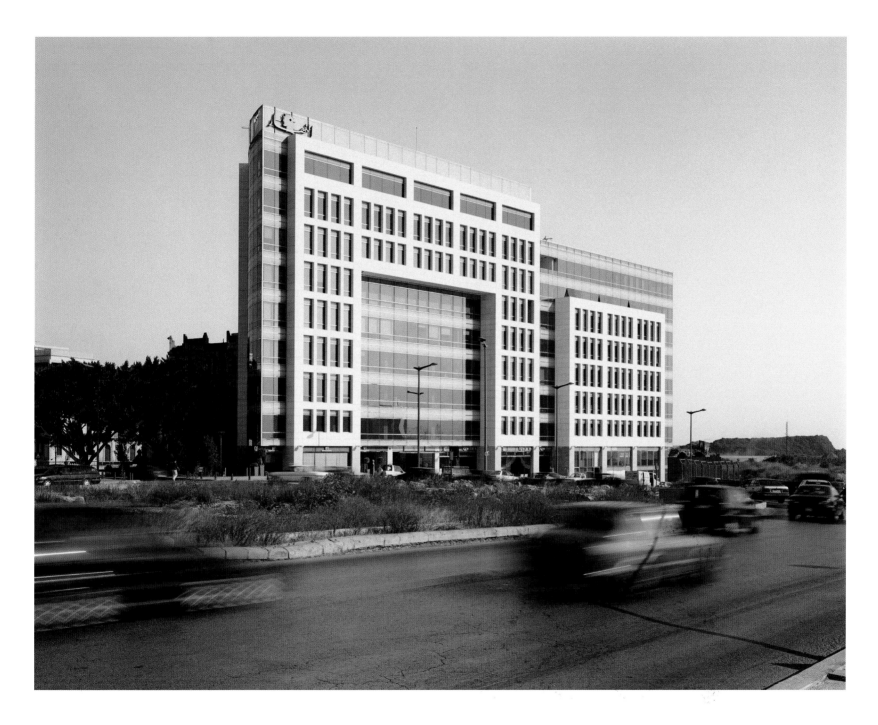

Construction of the Marina Towers residential building.

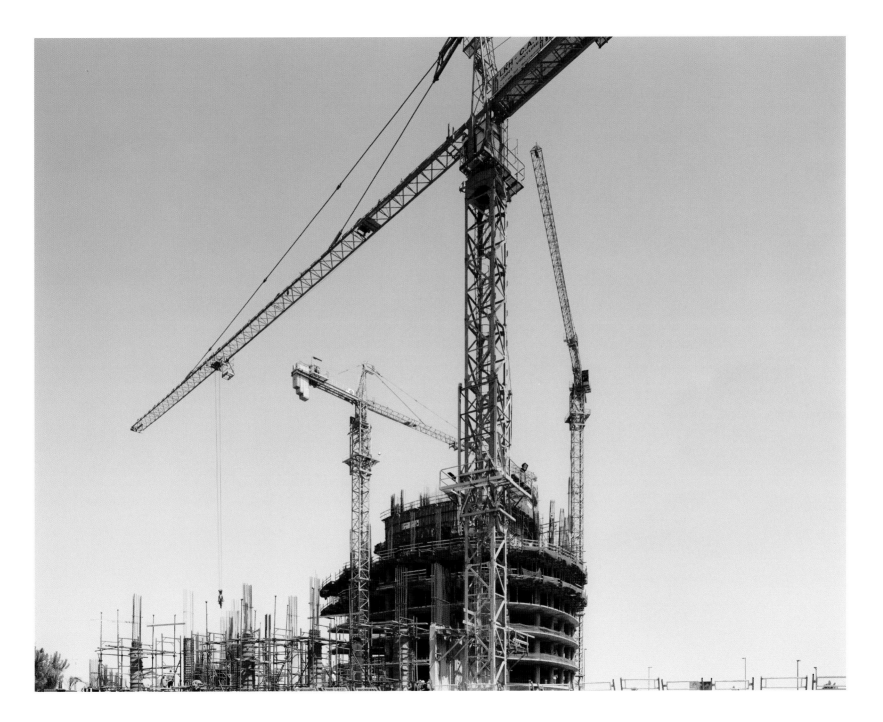

Marina Towers building site, with the city center in the background.

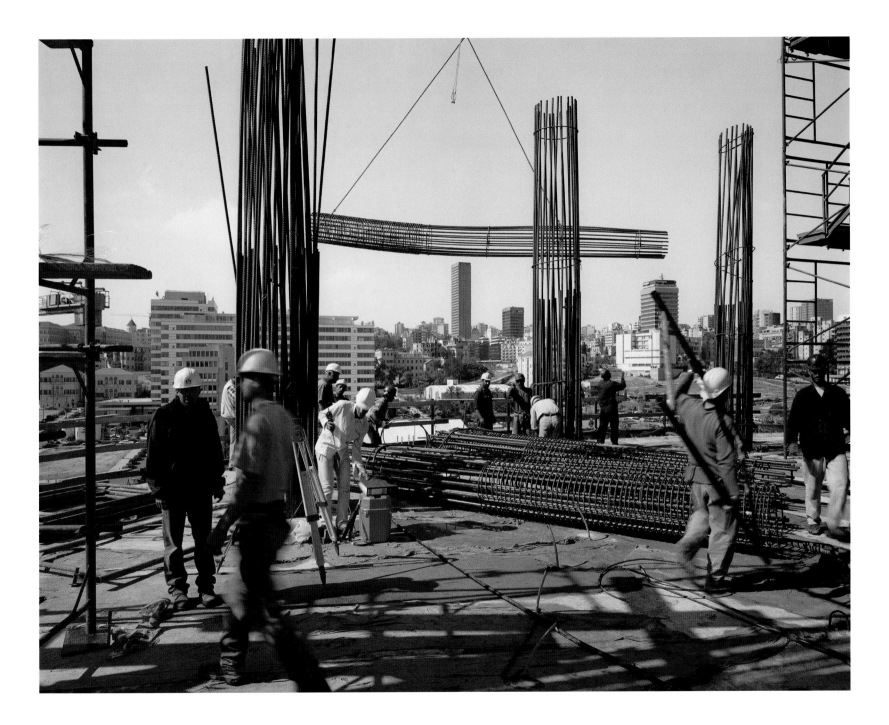

Banque Audi - Audi Saradar Group headquarters in Bab Idriss neighborhood.
Building designed by architect Kevin Dash.

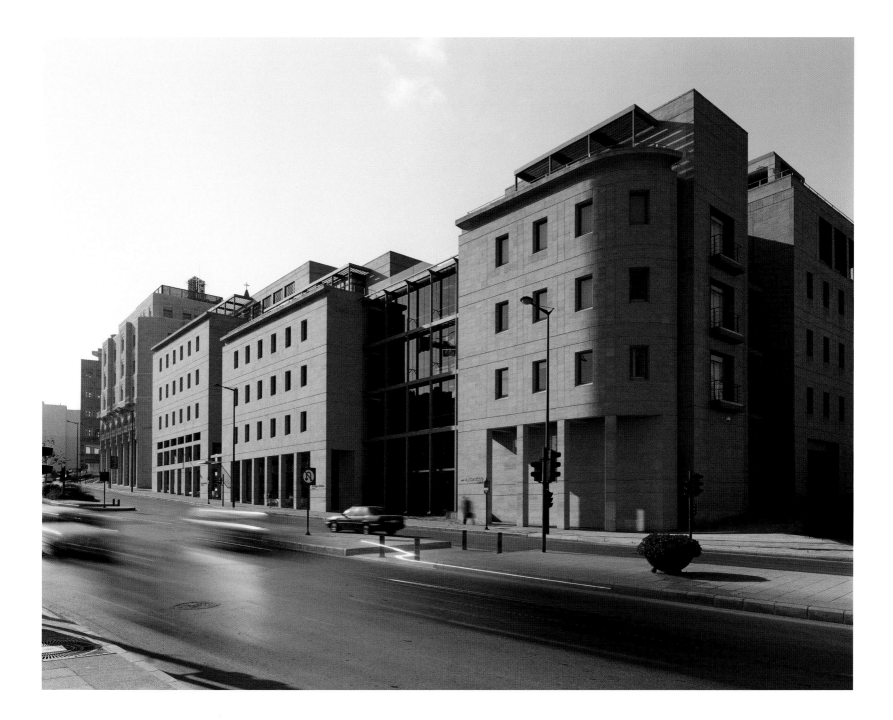

Banque Audi rear façade and piazza.

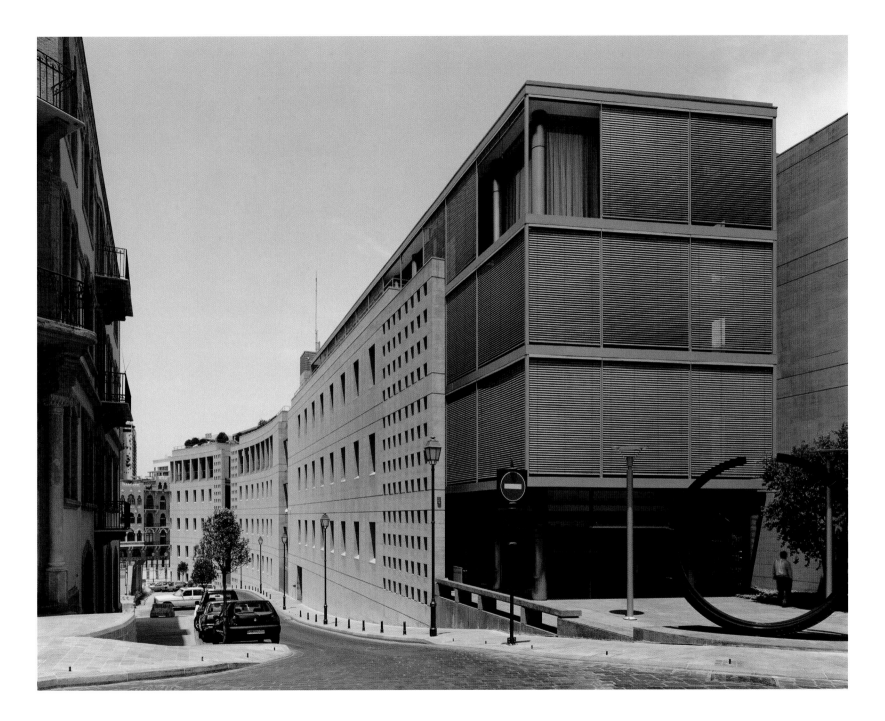

Maghen Abraham Synagogue, completed in 1926, Wadi Abou Jamil neighborhood.

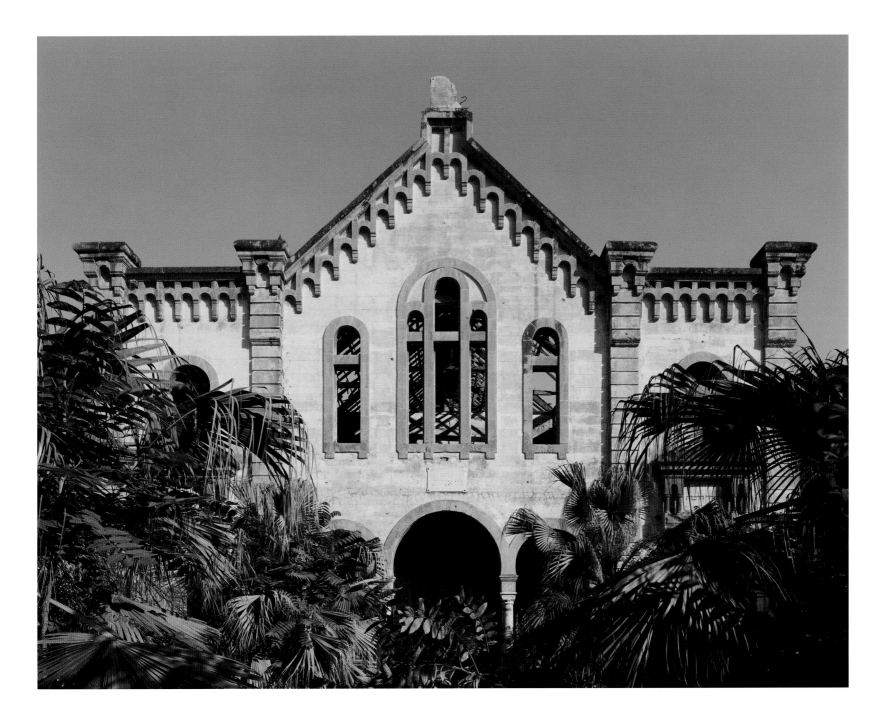

A traditional villa in the Wadi Abou Jamil neighborhood, with restored building in the background.

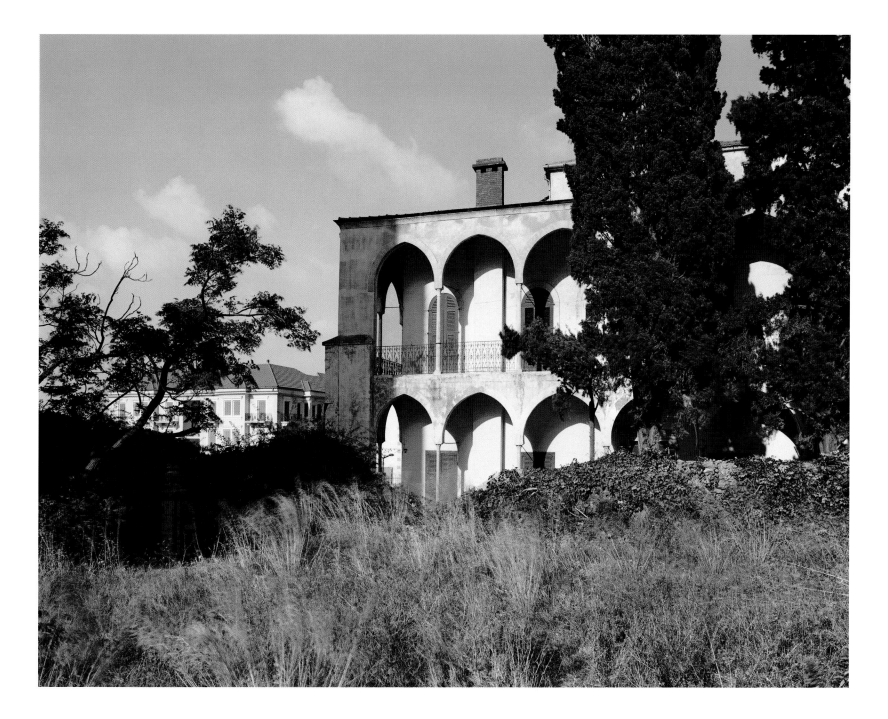

A Levantine private garden in Wadi Abou Jamil neighborhood.

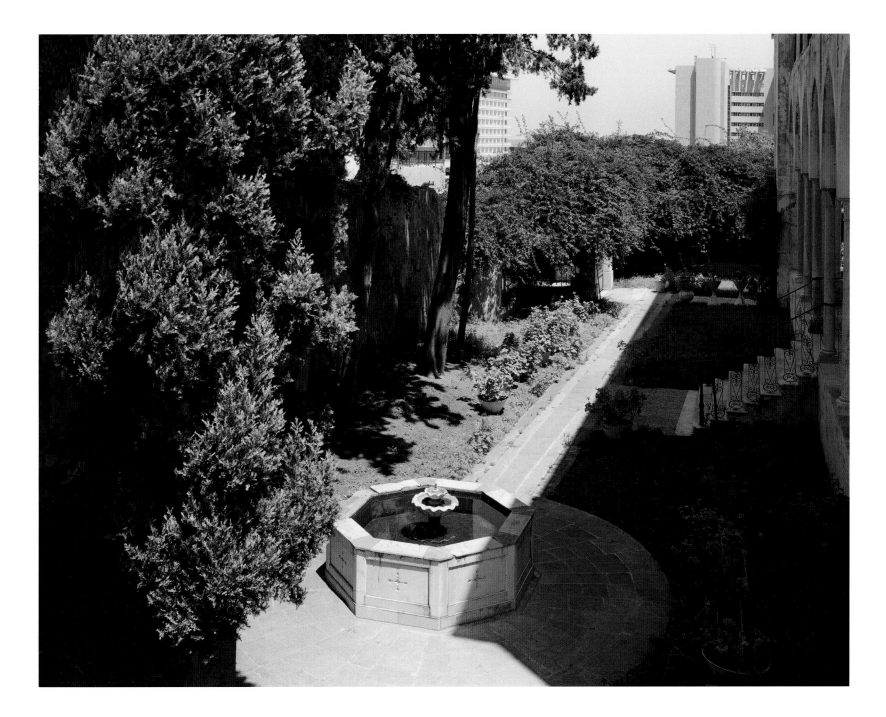

A turn-of-the-twentieth-century mansion housing a private art collection, in Zokak El Blatt residential area.

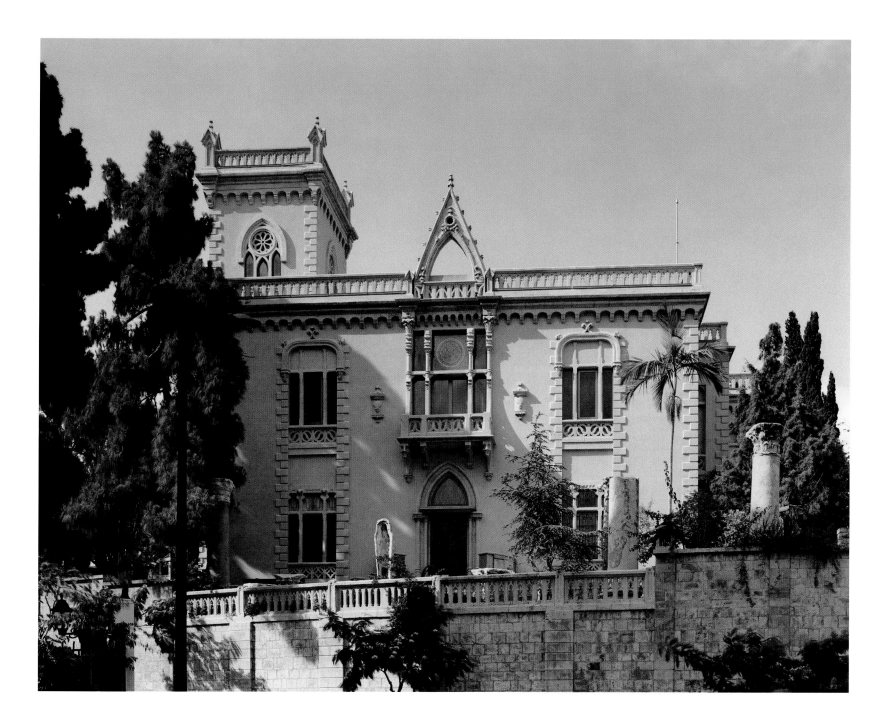

Zokak El Blatt residential area.

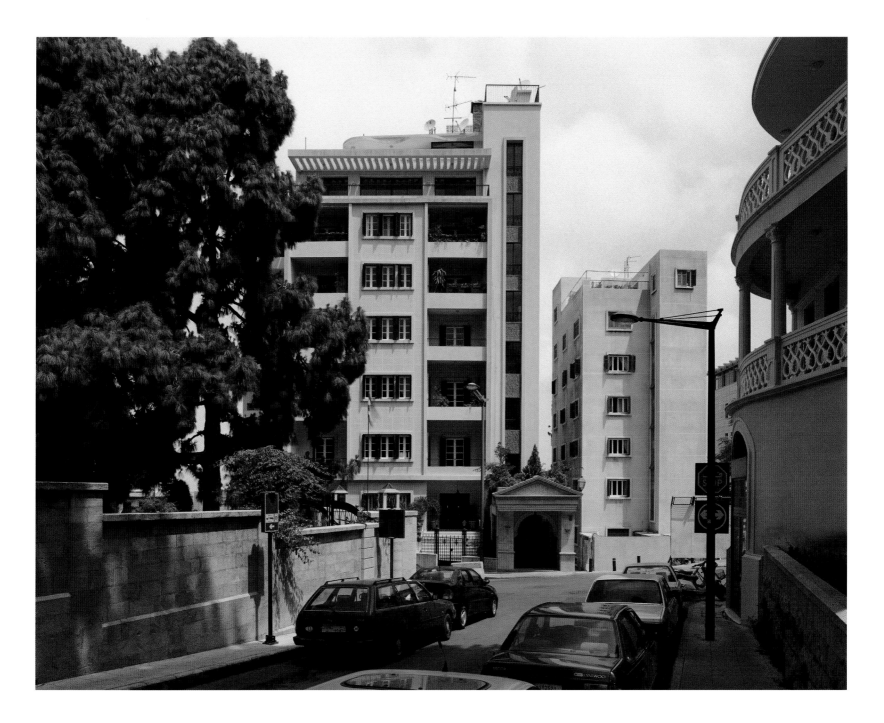

Saifi Village houses.

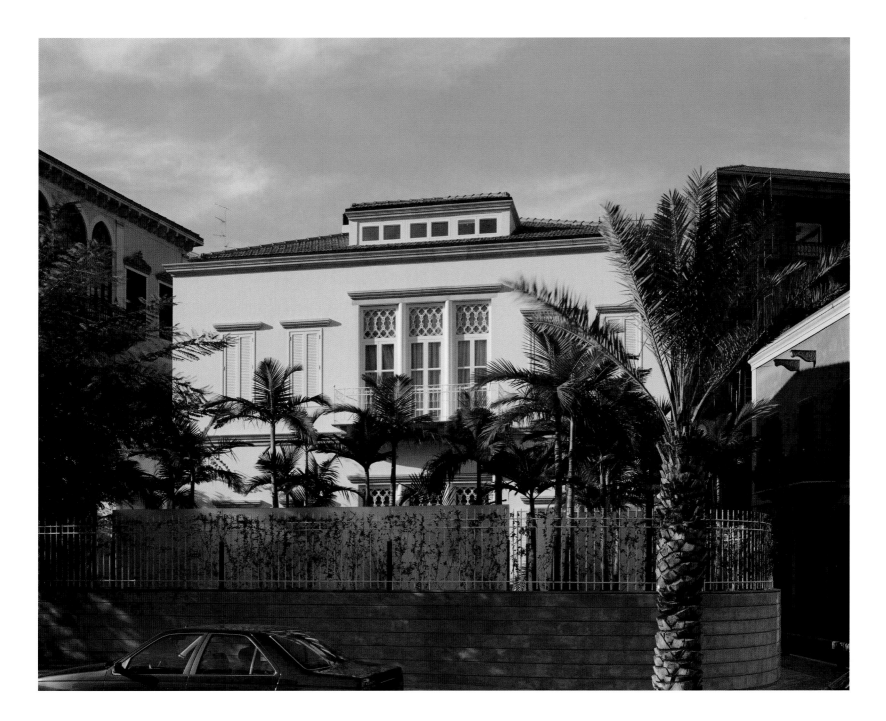

Saifi Village houses.

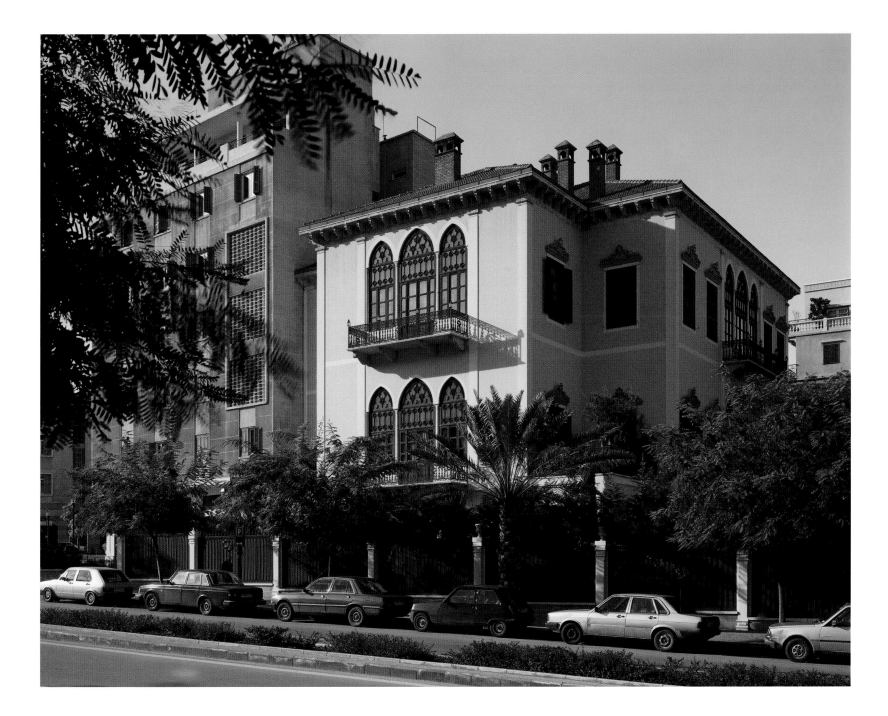

Saifi Village: a mixture of old and new buildings.

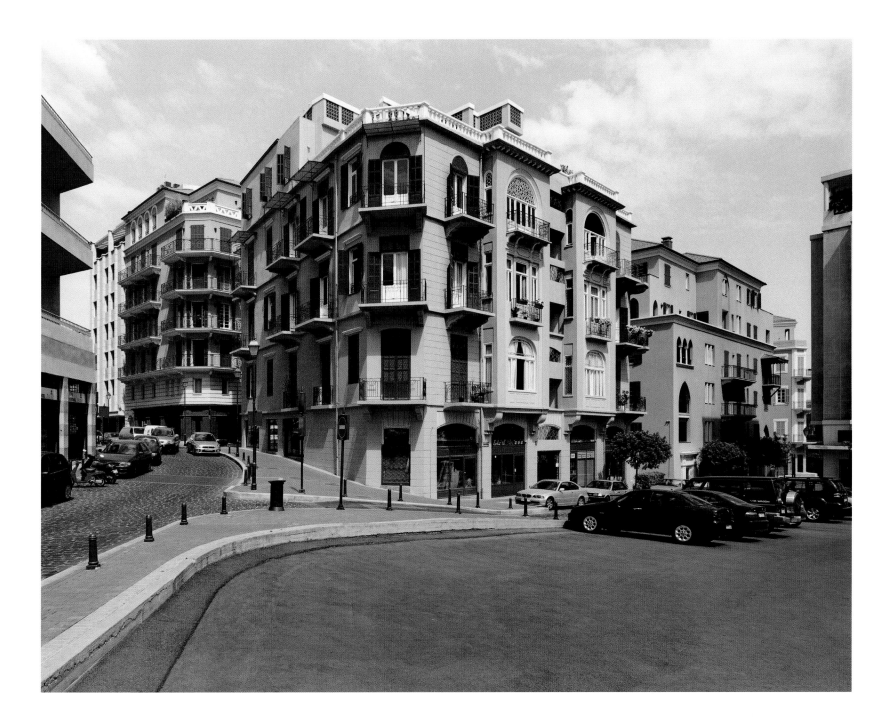

Saifi Village: a mixture of old and new buildings.

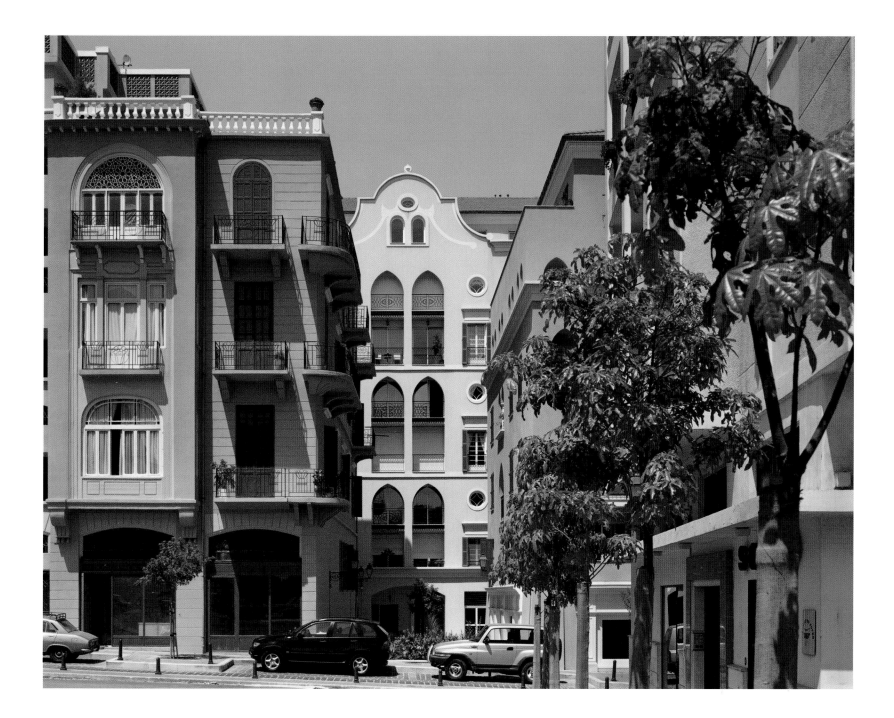

Saifi Village nursery school.

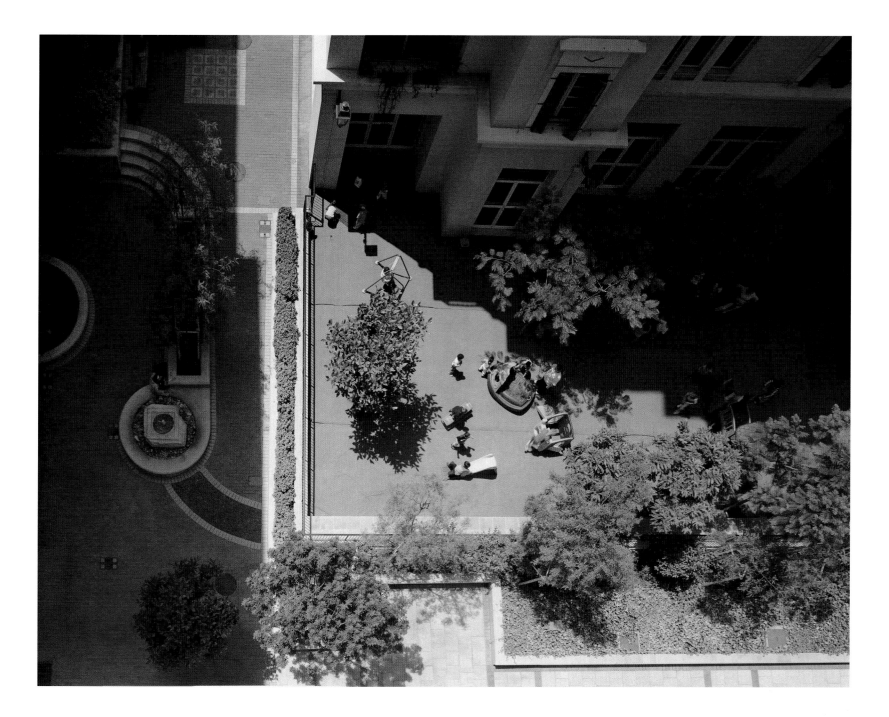

Saifi Village internal courtyard.

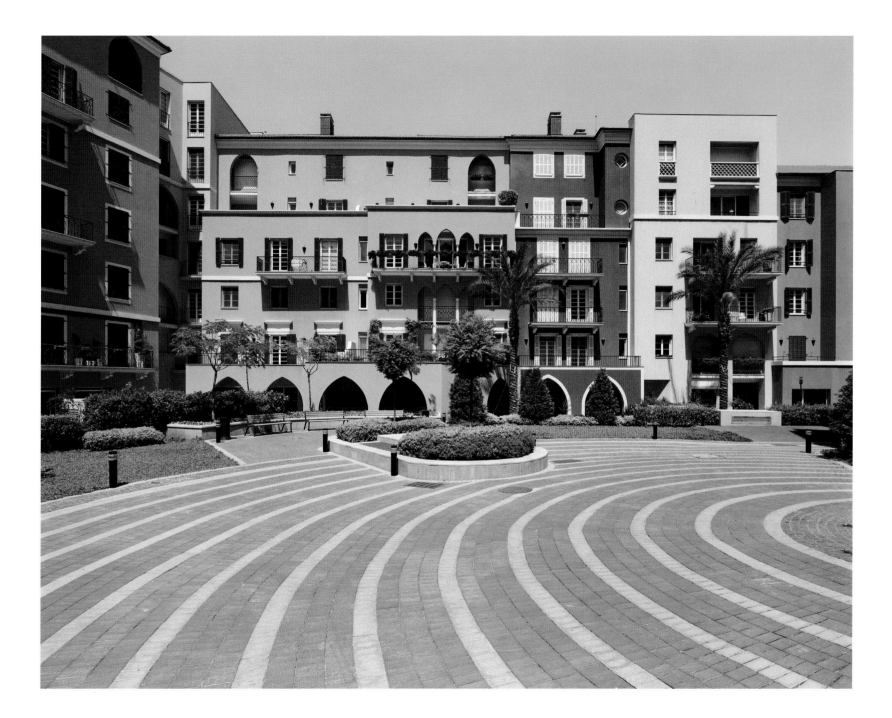

View from the north end of Foch Street, with Venice Center in the foreground and Abou Bakr (Al Dabbagha) Mosque behind it.

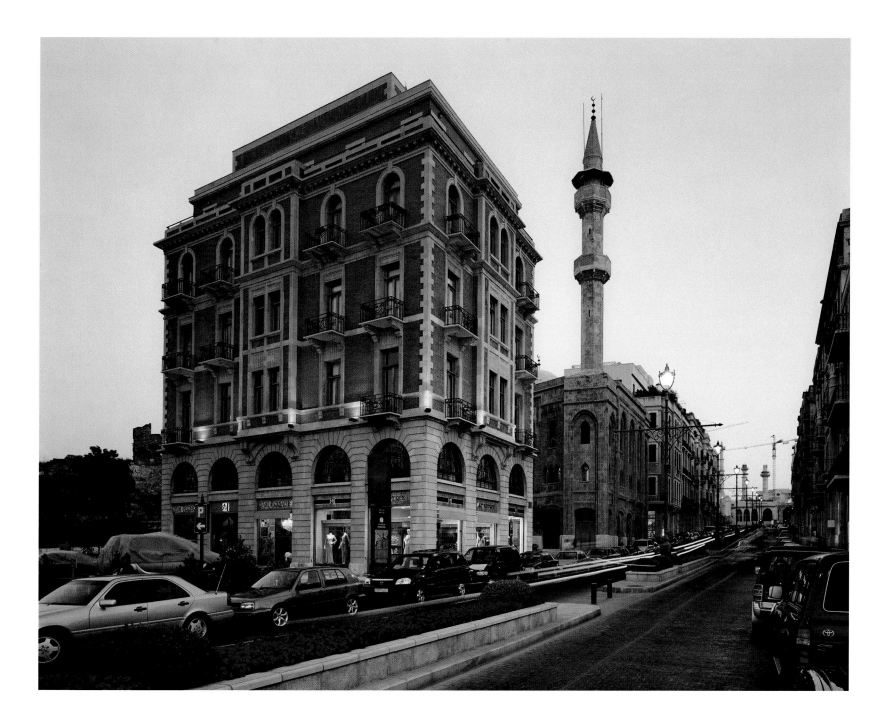

Amir Assaf Mosque, built in Mamluk-Ottoman style in the sixteenth century.

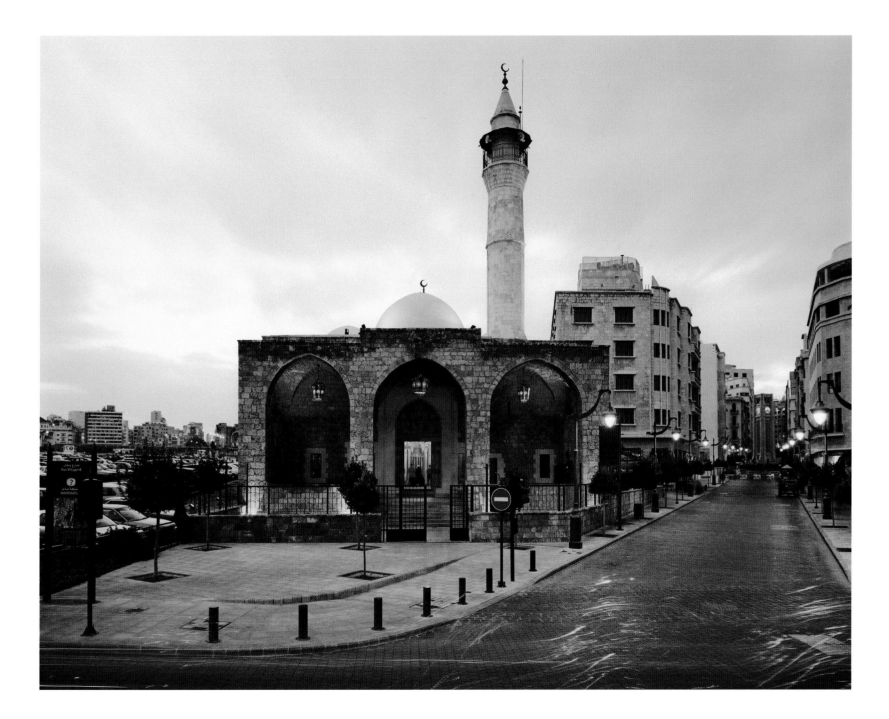

Maarad Street at dusk.

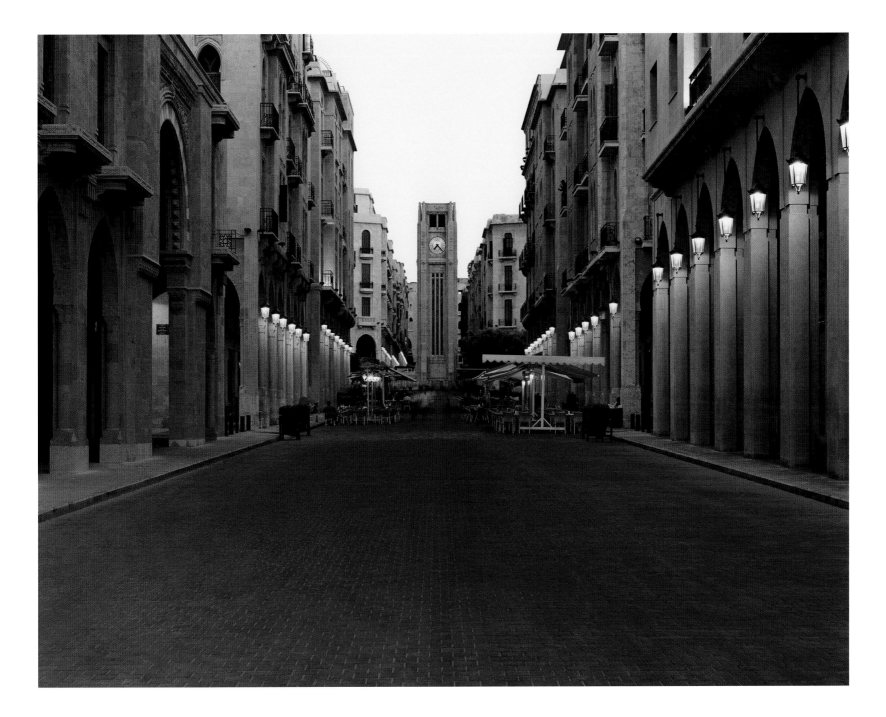

The Atrium, a new building on the corner of Maarad Street.

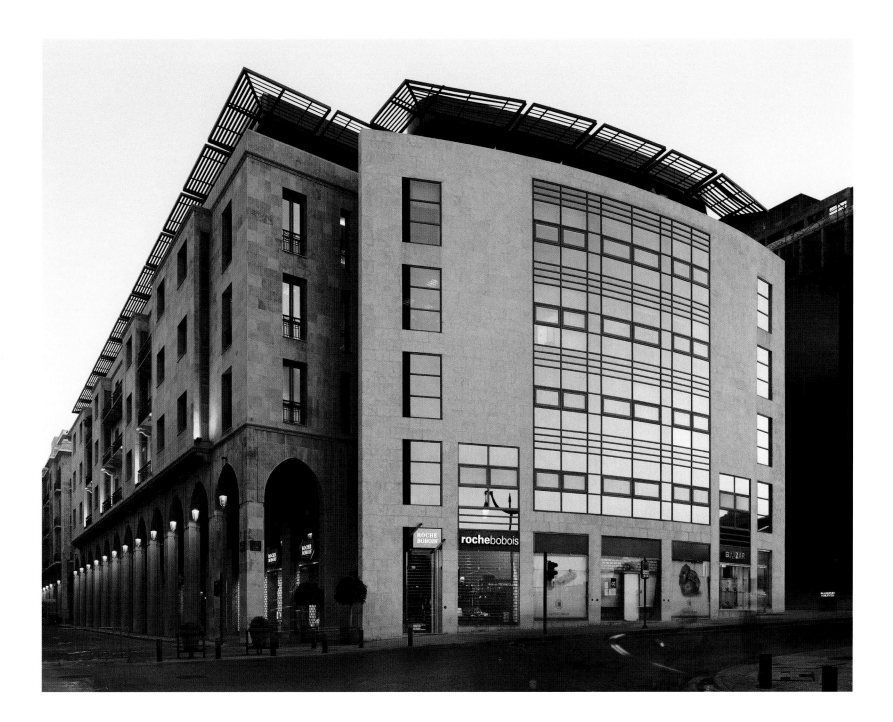

Parliament Building at dusk.

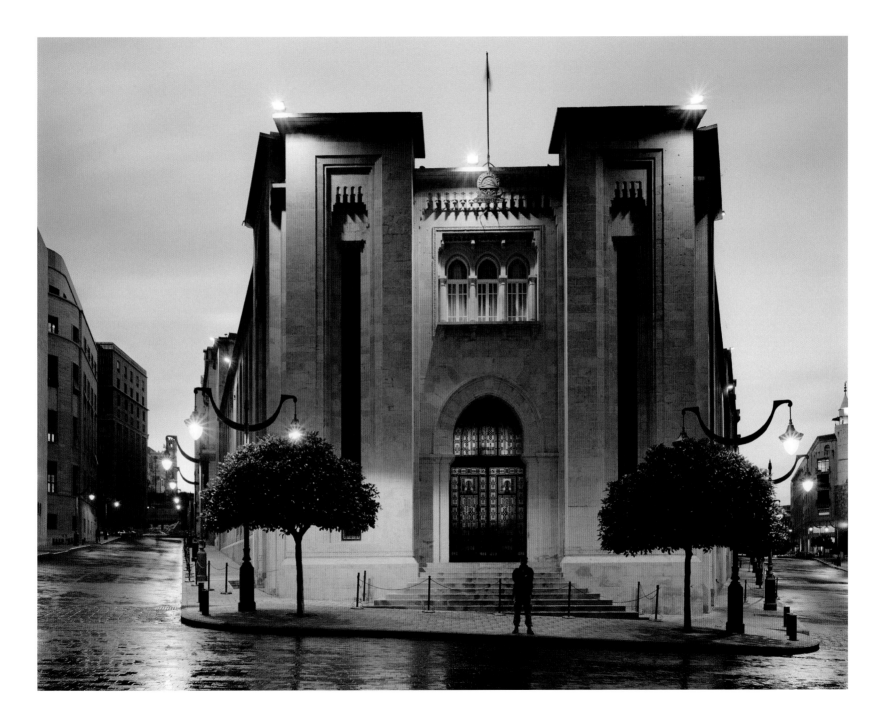

Open air concert at the Roman Baths.

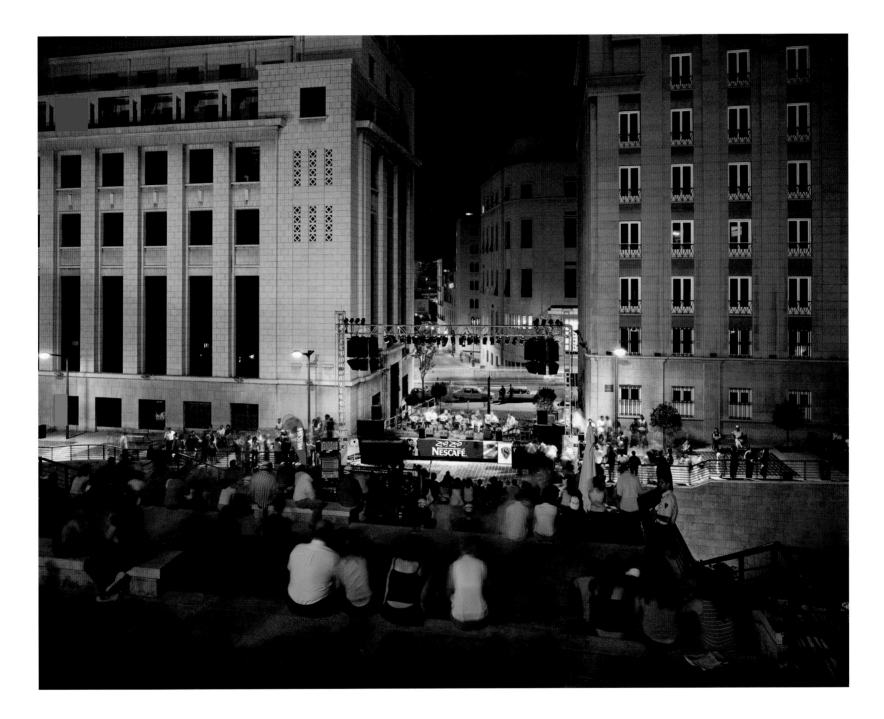

Café in the Foch-Allenby area.

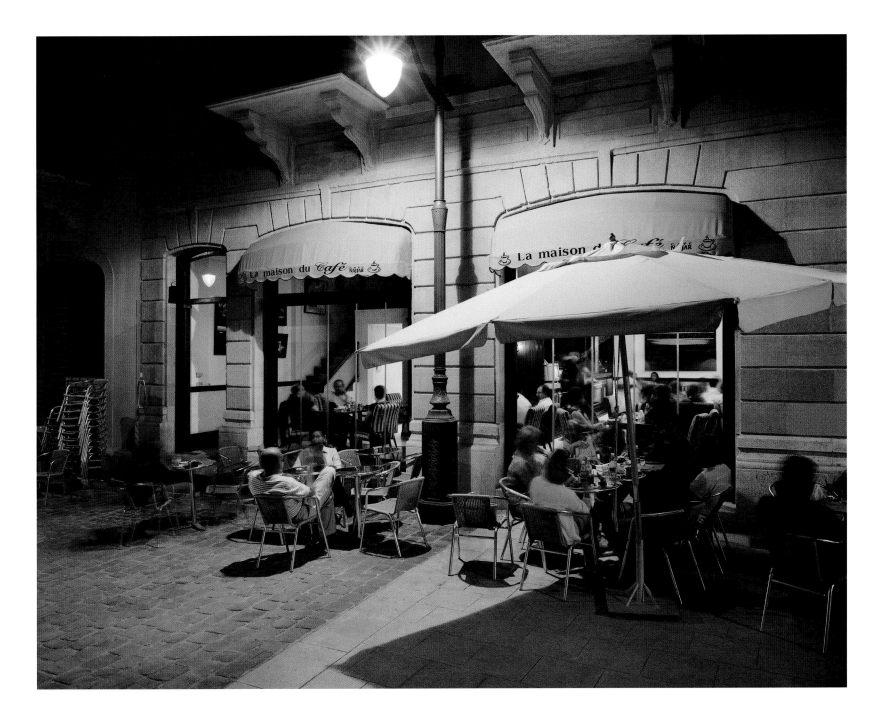

The restored National Evangelical Church. Built by missionaries in 1869, it was the first Beirut church with a red brick pitched roof, and its clock tower was the earliest in the city.

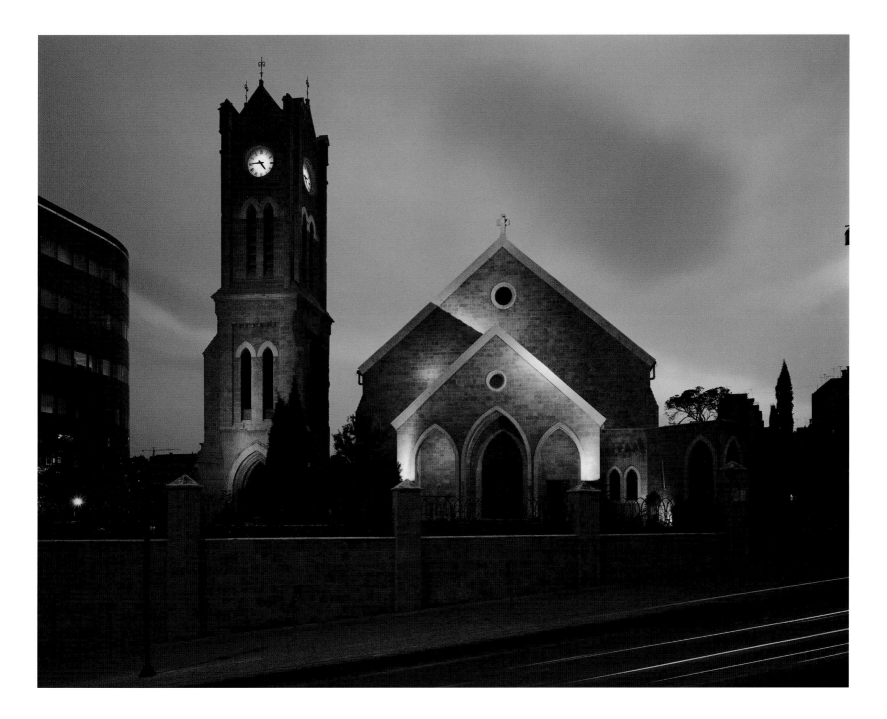

St Elie Armenian-Catholic Church.

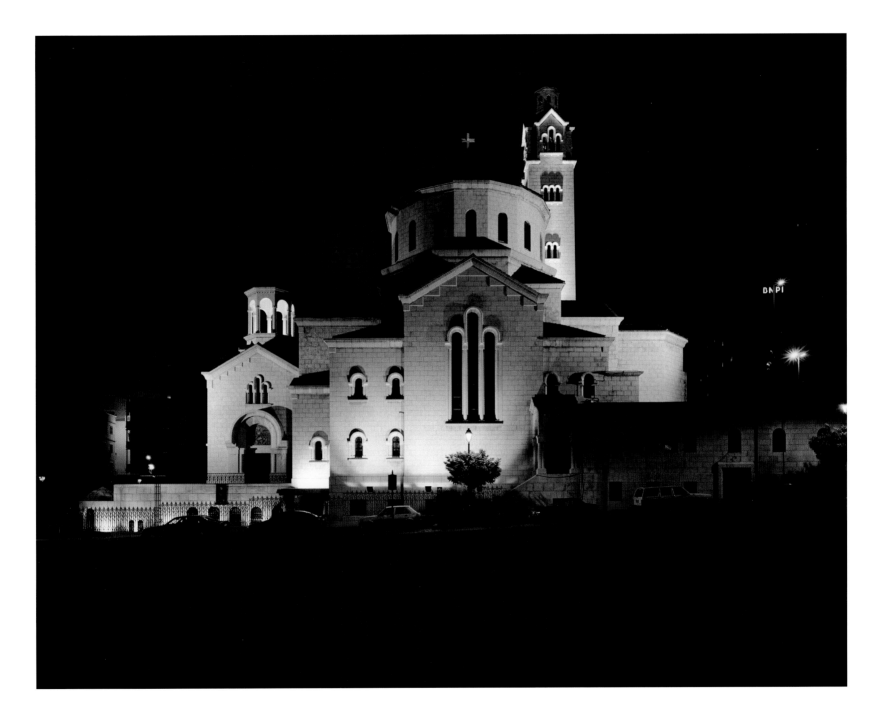

Department store in the Foch-Allenby area.

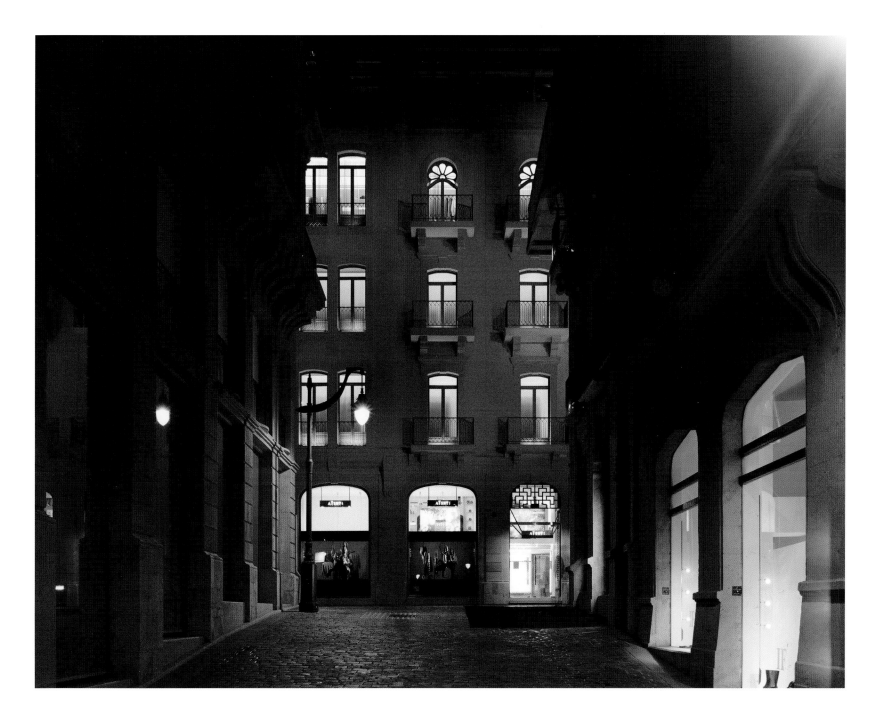

The Grand Serail at night. Built by the Ottomans as a military barracks in 1853, it was restored and enlarged in 1998 and is now used as the prime minister's offices.

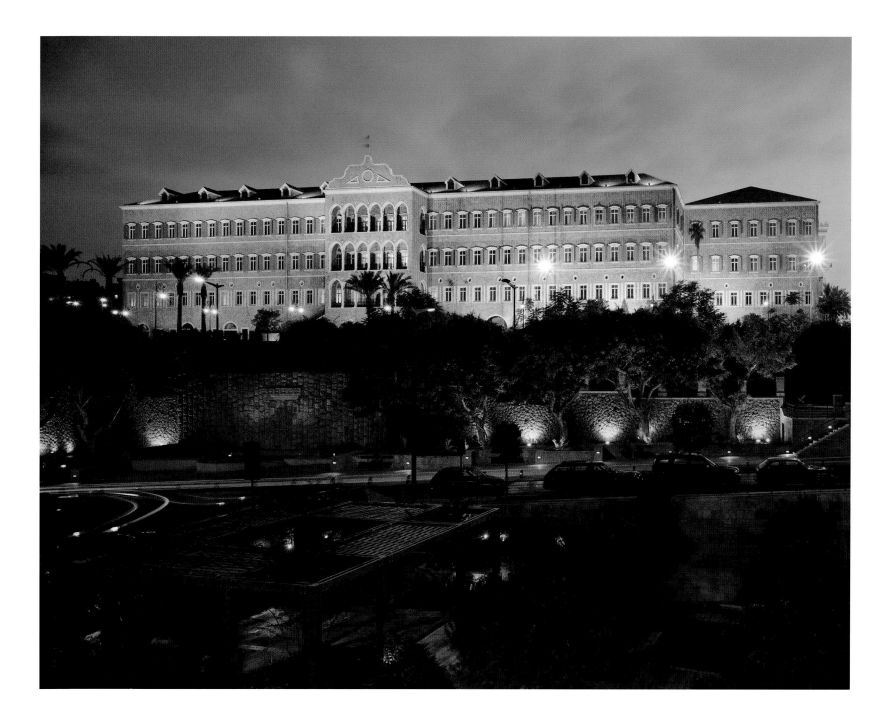

Winter view from the seafront promenade.

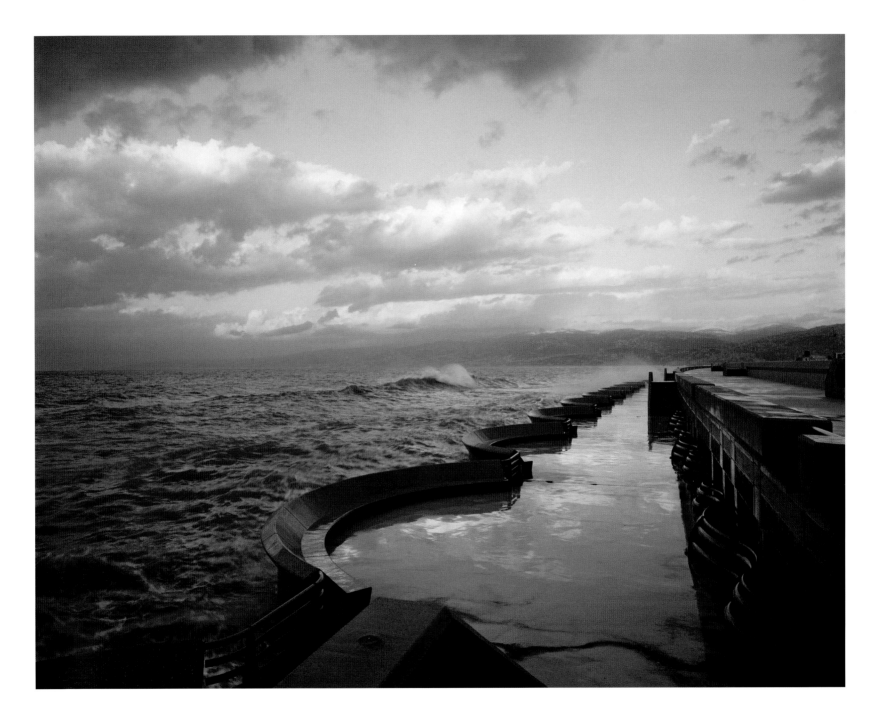

Acknowledgements

I was just finishing a book about the city of Memphis, Tennessee when, thanks to Stan Franklin and Jeannie Stonebrook, I met Nasser Chammaa, Chairman of Solidere, a prime mover in the architectural reconstruction of Beirut. Out of that meeting came the idea for this new venture, a book about Beirut's city center. I am very grateful to Nasser for giving me the opportunity to photograph there - I made four trips to Beirut, nine weeks in summer 2002, four weeks at Christmas 2002, four weeks at Christmas 2003, and 9 weeks in summer 2004 - and also for his steadfast commitment to quality in the publication of this book. There are many others to thank as well.

The day I arrived in Beirut I met Nouhad Makdissi, director of Solidere publications, who took me on my first magical walk through the city center. I appreciate her kindness and intelligence while educating me about Beirut and Lebanese culture. I thank her for repeatedly pointing me in the right direction, encouraging me to make my kind of picture, and making sure I had the resources to do good work.

I thoroughly enjoyed my time with Oussama Kabbani, an architect and one of the initial Beirut city center redevelopment planners. During my first three trips to Beirut, Oussama gave me tours of the city center, sharing his knowledge of it and giving me ideas about what to photograph.

I thank Dorothy Jabbour for skillfully coordinating the arrangements for me to go to Beirut and have a darkroom and work area when I got there. I needed many types and an endless number of permissions to photograph the different commercial, religious, and government buildings. I thank Ahmad Jaroudi for providing me with these essential letters of permission. I thank George Nour for attaining a number of additional hard-to-get permissions, and I thank Dorothy for coordinating all of them.

I thank Abdul Kader Chammaa and his staff for preparing an excellent darkroom and studio area. I thank Pierre Sabbagh, John Gulbenk, Raffy Kaloustian, and Hagop Saatdjian for being on my professional photographer support services team. I thank Roger Moukarzel for his friendship and eagerness to help. It was a pleasure to meet Sara Baban and I appreciate her collaborating with me and making possible the picture of the Montessori school children in Saifi Village.

Mohammad Labban, my driver, interpreter, and assistant during all my trips to Lebanon, went beyond the normal call of duty. Thank you for your essential help and good companionship! I am grateful for a personal four-day tour of Greater Lebanon with the historian and author Hareth Boustany that guaranteed my love for Lebanon.

Others at Solidere I want to thank are: Micheline Abi Samra, Raghdi Bizri, Radwan El Khatib, Jamal Soussan, Khalil Arab, Angus Gavin, Lola Gavin, Hans Curvers, Barbara Stuart, Mosbah Salam, Nabil Rached, Mosbah Assi, Mounib Hammoud, Houssam Hasbini, Diab Ayoub, Atef Hassan, Zahi Naamani, Randa Armanazi, Afif Soubra, Rita Boustany, Imad Dana.

In the United States, I am deeply grateful to my good friends Steve Foster, Dick Blau, and Tom Bamberger for generously giving their time to view the photographs and give useful feedback throughout the project. I am also grateful to Jed Jackson, chairman of the art department at the University of Memphis, for his support of me during this project.

Special thanks to Gerhard Steidl and his team at Steidl Verlag for beautifully rendering the pictures and text into a book.

L. E. M.

Biography

Larry E. McPherson was born in Newark, Ohio, in 1943. He has been teaching since 1978 at the University of Memphis, where he is an associate professor of art. He has received two National Endowment for the Arts Fellowships in Photography and a John Simon Guggenheim Memorial Foundation Fellowship in Photography. His photographs are in the permanent collections of the Art Institute of Chicago, the International Museum of Photography in Rochester, New York, the Museum of Fine Arts in Houston, and the Museum of Modern Art in New York City, among others. He is the author of *Memphis* (2002).

First edition 2006

© 2006 Larry E. McPherson for the images
© 2006 Solidere for this edition

Book design: Solidere
Scans by Steidl's digital darkroom
Production and printing: Steidl, Göttingen

Steidl
Düstere Str. 4 / D–37073 Göttingen
Phone +49 551-49 60 60 / Fax +49 551-49 60 649
E-mail: mail@steidl.de
www.steidlville.com / www.steidl.de

ISBN 3-86521-218-2
ISBN 13: 978-3-86521-218-4

Printed in Germany